Electronic Flash

Written and illustrated by Jack Neubart

the KODAK Workshop Series

Helping to expand your understanding of photography

Electronic Flash

Written by Jack Neubart
Photographs by Jack Neubart, unless otherwise credited

Publication KW-12e
Cat. No. E143 9855
Library of Congress Catalog Card Number 96-67853
ISBN 0-87985-772-2
Printed in Belgium

Kodak
LICENSED PRODUCT

KODAK is a trademark of Eastman Kodak Company used under license.
EKTACHROME and LUMIERE are trademarks of
Eastman Kodak Company.

KODAK Books are published under
license from Eastman Kodak Company by
 Silver Pixel Press®
 A Tiffen® Company
 21 Jet View Drive
 Rochester, NY 14624 USA
 Fax: (716) 328-5078
 www.saundersphoto.com

Contents

Introduction 5

Flash: The Lighter Side 6
Why Use Flash? 7
Built-In Flash 9
Special Situations For Built-In Flash 10

The Nature of Light 12
Sunlight and Flash Compared 13
Diffused and Soft Light 16
Frontal and Overhead Light 17
Sidelighting 18
Backlighting and Rim Lighting 19
Lighting With On-Camera Flash 20
Basic Exposure and Contrast 23
Camera Metering Systems 24
Understanding Contrast 24

Flash Basics 26
Basic Settings and Preparations 27
Dedicated Flash 27
Flash Synchronization 29

Accessory Flash Units 34
Shoe-Mount Flash 35
Handlemount Flash 37
Off-Camera Flash 39

Electronic Flash Control 40
The Basics of Flash Exposure
 Control 41
Using the Guide Number 45
Exposure Modes 46
Exposure Compensation With
 TTL Flash 47

Automatic Flash Control 49
Manual Flash Control 50
Exposure Compensation With
 Automatic and Manual Flash 51

Film and Filters 52
Film and Flash 53
Filters For Color Correction 53

Creative Control 56
Modifying Flash Output 57
Bounce Flash 58
Eliminating Red-Eye 61
Fill-Flash 62

Fun Flash Adventures 66
Flashy Silhouettes 67
Friendly Ghosts 67
High-Key and Low-Key Lighting 67
Painting With Light 68
Flash Effects With Filters 69
Slow-Sync Flash 70
Second-Curtain Sync 70
Stroboscopic Flash 71

Advanced Flash Techniques 72
Multiple Flash 73
Multiple Lighting With TTL Flash 73
Wireless TTL Flash Triggering 73
Multiple Lighting With
 Manual Flash 74
Wireless Manual Flash Triggering 74
Close-Up Flash 75
Macro-Bracket Lighting 76
Ring-Flash Lighting 76
Studio Flash 79
Umbrellas and Softboxes 80

Additional Light Modifiers 81
A Basic Photo Studio 82
The Flash Meter 84

Putting Flash to Work 86
Portraiture and Portrait Lighting 87
Flash Outdoors at Night 90
Flash With Pets 90
Flash at the Zoo 92
Flash at the Marine Aquarium 92
Copying 93
Still Life 94

Electronic Flash Troubleshooter 96

Glossary 104

Appendix I
Flash Maintenance 108

Appendix II
Battery Care 109

About the Author

Jack Neubart is a freelance photographer and writer, and the author of *The Photographer's Guide to Exposure* (Amphoto, 1988) and *Industrial Photography* (Amphoto, 1989). He produces work on a variety of photographic subjects, including digital imaging, for a number of publications, among them, *Photo District News, The Commercial Image, Studio Photography,* and *Popular Photography*. He has also seved as an editor for two professional photo magazines. He has taught photography at New York's School of Visual Arts and has lectured at other institutions. In addition, he is the author of the ARPEGgIO™ keywording lexicon for stock photography.

Acknowledgments

The following equipment played a key role in producing this book: Canon EOS SLR cameras, particularly the EOS A2 and EOS Elan IIE; dedicated Canon Speedlites 430EZ, 380EX, and Macro Ring Lite ML-3; and Metz 45 CT-4 handlemount flash; together with Sekonic and Polaris flash meters.

The author would like to thank Eastman Kodak Company for providing samples of the latest EKTACHROME Films for use in this project and to the following companies for their help and support in providing information and services, and where applicable, additional equipment: Baboo Color Labs, Bogen, Brandess-Kalt-Aetna, Canon USA, Ikelite, Minolta, Nikon, Pentax, Photoflex, RTS, The Saunders Group, Sto-Fen, and White Lightning/Paul C. Buff. (This is not an endorsement of these companies or their products. Similar results can be obtained with comparable products from other manufacturers.)

Wholehearted gratitude goes to National Geographic photographer Bob Sacha, for travel and technical suggestions; Patricia and Greg, for their help in shedding new light on familiar topics; Eric and Nava, for their unwavering positive attitude, not to mention braving the numbing cold just to help a friend; Josh and Esther, for providing a warm shooting environment; photo rep Susie Miller, for providing smiling faces and her good nature, and Bob for holding the reflector during this photo session; Michelle and Jeffrey, for the hours they endured in the bone-chilling weather; Kerry, for extending the welcome mat and providing a variety of photogenic subjects; RTS's Mark Tahmin and Mike Stango, for practical pointers; the kind people associated with the Madeira Wine Company, in Madeira and the US; and to all those other people who modeled for this book. The author especially appreciates the tireless technical assistance provided by Canon's Chuck Westfall. A special thanks also to Silver Puxel Press' Jeff Pollock for his guidance in this project.

The author dedicates this book with love and longing to his cat Prudence, who taught him the fine art of patience, and to his mother and father, who taught him everything else.

Note: The author, publisher, and Eastman Kodak Company assume no liability in the event problems with your particular camera/flash system occur as a result of information provided in this book. While this information is based on a combination of the author's personal experience with various pieces of equipment together with extensive research and consultation with experts in the field of flash photography, it is impossible to field-test every camera and flash and all the possible combinations and permutations. Used appropriately, the material covered in this book should enhance your photography and provide countless hours of enjoyment with your camera and electronic flash.

Introduction

Electronic flash became popular long ago as a portable and economic light source. With it at our disposal, we no longer had to carry around a bag full of flashbulbs or worry about burning our hands on a spent bulb. Each advance in electronic flash technology heralded more and more advantages, presented more and more creative opportunities, provided countless flashes of inspiration.

Still, why do we use flash and why electronic flash in particular? We use flash because we do not have enough ambient light to make a good picture. At home we could always switch to a stronger light bulb or bring another table lamp into the room, but that's not a practical solution in every indoor situation and certainly not outdoors. We need a light source that we can control and often one that will go anywhere the camera goes, flexible enough to meet any number of challenges head-on. Electronic flash is the answer.

Flash: The Lighter Side

We begin our discussion of electronic flash by revealing the world in a way not customarily seen by available light. From there we move on to the most readily available portable light source: built-in flash, and review all it has to offer, as well as its limitations. Next we test this small but capable light source to learn firsthand what it can do.

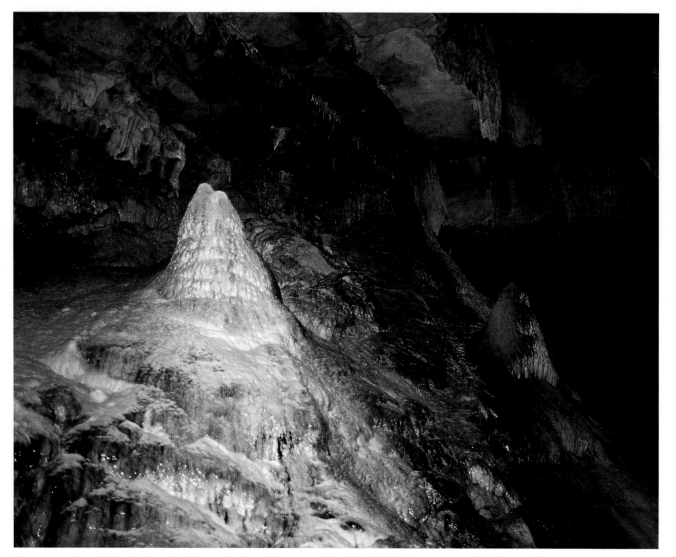

In a cavern deep within the bowels of the earth, where it is perpetually night, flash brings out many details not otherwise seen, even in a tourist cave such as New York's Howe Caverns, where spotlights focus on featured attractions. Typical of flash illumination, the light falls off in the distance.

Why Use Flash?

Electronic flash provides innumerable opportunities to take pictures where we couldn't ordinarily take them and with a clarity that could not happen otherwise.

Flash: The night light

When it gets dark, flash provides the alternative to working with long shutter speeds by available light. Beyond that, flash may be the only choice when confronted with a dark void—no light anywhere, except from a lone street lamp or a waning moon filtering in through a window or just barely lighting a path outdoors.

Using flash can make a subject stand out at night against the darkness. A person illuminated by flash, standing in front of a dark city street, takes on a stark reality that pops out at you in the picture. Given the right conditions, it's even possible that flash will produce a similar effect in daylight or other available light, if the background light levels are not too strong.

Flash-freeze

Camera shake is always a problem when taking pictures under low lighting conditions. Flash easily relieves anxiety over getting sharp pictures at these times. The flash picture is sharp and crisp.

Yet it's not simply camera shake that is of concern. Sometimes we really want to stop the action dead in its tracks. The shutter speed in the camera may not be fast enough to achieve this effect alone. The solution is flash. Flash can deliver a burst of light that may be as fast as 1/30,000 second, which is more than enough to freeze most of the movement we encounter daily. Many strobes, when used in their manual mode, as well as with many very small flash units, may not provide as short a burst of light energy, but still they can freeze any average activity, such as people dancing at a party.

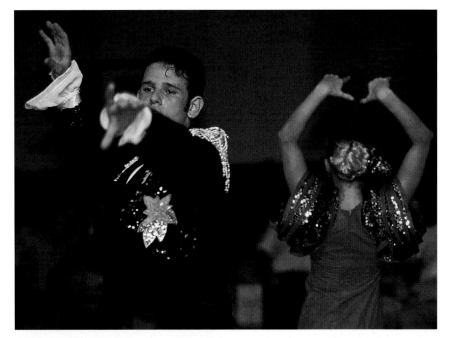

Available lighting could not have captured the spirited movement of these Madeiran dancers the way electronic flash did, freezing a peak moment in the dance.

Using flash with a long shutter speed can produce lively, unpredictable results. A static night scene at a banana plantation in Funchal, Madeira, suddenly gains an eerie vitality as available street lighting mixes with flash. The camera was handheld and the photographer moved it during the exposure to produce the streaks.

Flash blur

Flash does not preclude the use of long shutter speeds or time exposures. Some very inventive photographs are possible when there are bright, color-ful light sources in the background. Contrast a foreground subject illuminated by flash against floodlights, neon, or the lights on Broadway. Those background lights might even create wonderful swirls or streaks of color if they're in motion, such as amusement park rides or moving traffic.

Beautiful blurs of color are not limited to background lights. With a long shutter speed, a moving subject draped in color can create a blur of hues and shades on top of a sharp, flash image.

Flash for depth of field

Flash not only stops action to give us sharp images. Adding light from the flash may let us use smaller *f*-stops, and that means greater depth of field. Depth of field is the zone of sharp focus in the picture. The smaller the *f*-stop or aperture, the greater the depth of field—more of the picture around the subject looks sharp. Other factors also affect depth of field, but they are not related to flash photography the way the lens aperture is.

Flash as fill

Even daylight exposures benefit from flash. If a subject is in shadow while everything in the background is lit beautifully, flash can provide that extra source of light to fill in those dark, indistinct areas where the available light cannot reach the subject. In short, acting as a fill light, the flash brings the shadowy facets of life to light.

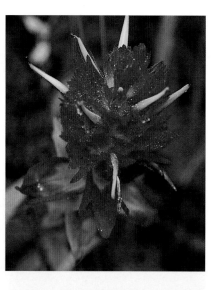

Strobe lighting made it possible to stop down to a smaller lens aperture, providing greater depth of field, hence increased sharpness in depth than what was obtained with an available-light image.

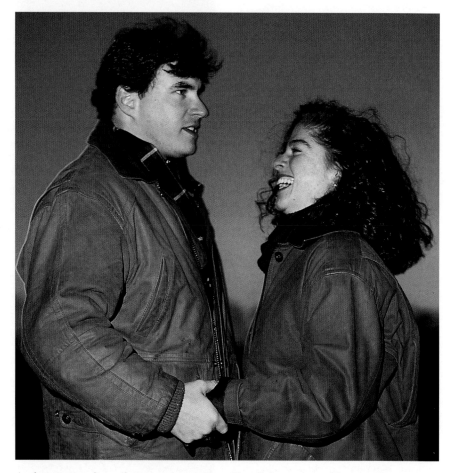

As the sun went down, there wasn't enough ambient light to expose this romantic young couple. The shutter speed was too slow to prevent camera shake for a handheld exposure in the numbing cold. Using flash, controlled with the camera's multi-pattern metering system, provided the necessary fill light to illuminate the couple while maintaining the warmth of the scene.

Built-In Flash

Next to daylight, the ubiquitous built-in flash is the most convenient light source available. A great many 35mm point-and-shoot and single-lens-reflex (SLR) cameras are now available with a built-in flash. Depending on camera design, the flash may be activated either automatically or with the push of a button or flick of a switch. Some flash units pop up, again either automatically or manually; other flashes have a fixed position.

Flash units are being built into 35mm SLR cameras with increasing frequency. Not only is this strobe handy and convenient, but it really can deliver. It may not boast the extended capabilities of its larger siblings, but this little strobe can provide features such as TTL flash control, red-eye reduction, and automatic fill-flash.

On SLR cameras, the built-in flash takes center stage, seated above the viewfinder. As a rule, when a built-in flash is in operation, an accessory strobe cannot be used at the same time. However, there are exceptions where the built-in flash and an external on-camera strobe can work together. For now, let's just assume all we have is that one small, built-in light source.

Built-in flash: The pros

Built-in flash was designed to be readily available. Unfortunately, we often find ourselves using the built-in flash in situations where it was not meant to be used and not using it where it might do the most good. What are the appropriate moments? Why use it in the first place?

With regard to the point-and-shoot lens-shutter camera, the built-in flash is the only practical source of extra light. As for the SLR, it means you don't have to carry another flash. Once the add-on flash goes inside the camera bag, so do all the connecting cords, extra batteries, and flash accessories, and all this begins to make a fun day with the camera a big chore.

If you leave the extras at home, you have less to carry, you won't waste time looking for the flash, you have less to worry about, and less to be bothered with. With the built-in flash, you can be more spontaneous.

Also, this ultra-compact flash was designed as a natural extension of the camera. It doesn't make the camera awkward to work with. Adding an accessory flash on top of the camera makes that compact SLR top-heavy. This may be enough to tip the camera upside down so that it doesn't hang naturally from the neck strap.

Moreover, because the built-in flash pops up, you know it's turned on. With an accessory flash that doesn't shut off automatically, you have to keep turning it on and off so as not to waste batteries, and you might take the next picture by accident without flash.

In a word, that built-in flash spells C-o-n-v-e-n-i-e-n-c-e, with a capital C.

Built-in flash: The cons

So why not rely on the built-in flash in every situation? Unfortunately, it does have several shortcomings. The built-in flash is powered by the camera battery. Expected battery life may be cut in half if the flash is used consistently.

To conserve battery power, the built-in flash is not designed to be very powerful. Its distance range is very short. It's slow on the uptake: It requires what may seem like a lifetime—a second or two—for the flash to reach a full charge after it's been

Built-In Flash: Pros & Cons

Built-In Flash/The Good...When this youth stuck his head out of the bushes in an attempt to scare passersby, the built-in flash was there to capture the moment. The spontaneity of the event and the prevailing darkness on this quiet Madeiran street called for a simple and expedient approach: It was much easier and definitely faster to press the flash pop-up button than to search through a camera bag in the dark for an accessory strobe. A few seconds later and the moment would have been gone.

Built-In Flash/The Bad...Built-in flash units are not very powerful and can only cover a short distance. The photographer was too far away for the built-in flash to properly expose the scene.

fired. External strobes (with fresh batteries) can reach the flash-ready status in fractions of a second.

The flash may fail to cover the full field of view of some very wide-angle lenses. You may wish to use a 24mm lens but find that the built-in flash covers lenses only as wide as 28mm. The use of this flash with the wider lens will result in only partial flash coverage, vignetting will occur in the corners of the image. Also, because the built-in flash sits low on the camera, long lenses and lens shades may block part or all the flash light from hitting the subject, thereby throwing the subject in shadow. The camera's instruction manual will usually provide recommendations to help avoid such predicaments.

If you're an SLR user concerned with this problem, solutions will present themselves along the way. But in the interim, if it looks like the emitted light will hit the lens, take precautionary measures, such as removing the lens shade or switching to another lens that has worked well with this flash in the past—if that will provide a reasonably good photograph. Other choices include slipping a hot-shoe flash on the camera, or using off-camera flash (with the proper sync cord). These other flash options will be discussed in greater detail further on in this book. Before changing anything, make one exposure and note the frame number and equipment used. This will ascertain if indeed a problem would occur with a particular combination of lens and flash.

Special Situations For Built-In Flash

Built-in flash outdoors at night

Suppose you're with friends on a trip to New York City. It's getting dark, and you're standing several feet in front of the illuminated fountain outside the Plaza Hotel. You want to get your friends in the picture with the

Did the photographer get his shadow in the picture at the bottom of the frame? No. The culprit is an oversized lens blocking a portion of the light from the built-in flash, ruining this colorful shot.

fountain. They, in the meantime, decide to scatter, with some several feet behind the others and closer to the edge of the fountain. So you step way back, maybe 30 feet or so, to get them and the fountain in the shot, and take a flash exposure. Why didn't the picture come out the way you'd expected?

As mentioned, built-in flash units are not powerful enough to illuminate subjects at this distance. Camera instruction manuals usually provide usable distances for different-speed films. If ISO 100 film is used, that distance could be 15 feet or perhaps 20 feet: It varies with the design of the flash and camera.

Unfortunately, this information is not always provided, and it may be necessary to contact the manufacturer's customer service department or your photo dealer to get this information. If all else fails, be conservative and use 10 to 12 feet as the maximum shooting distance. With ISO 400 film, that distance stretches out to 24 feet.

Now, in this scene, even if you had come in close enough for the flash to properly expose your friends in front, light falloff behind them meant there was little chance of including those

standing farther back with that singular flash burst. You've encountered similar situations before—only not with flash.

You're sitting next to a table lamp reading a book, but if you move to the other side of the room, you find there's not enough light there to read by. Just as light from a reading lamp illuminates only to a certain distance, the same holds true for flash. The flash firing from a closer distance might produce enough light to reach your friends in the foreground, but it falls off to the point where it is much too weak to fully illuminate the people in the background and the fountain. Another problem that might crop up: The subjects in front could cast shadows on those in back. One possible solution would be to photograph your friends in a close group, preferably lined up alongside, instead of in front of, the fountain.

Another option goes into more advanced territory. Your camera may have a special slow-sync or night mode that combines a long ambient exposure with flash. The slow shutter speed would capture the fountain illuminated with floodlights in a soft blur washed in warm light, and the flash lights your friends standing in front.

Built-in flash indoors with groups

For the same reason that flash won't adequately cover that scene of your friends against a fountain, flash may not cover a crowded room. The flash may only reach the people in front, or the light may be blocked. The result is a flash exposure that only illuminates the people closest to the camera and leaves a diminishing trail of light, so people in the background are almost, if not entirely, in the dark.

To photograph this scene, situate yourself in a more advantageous position by climbing up on a solid chair or other sturdy surface that provides a firm support. Just be careful and

Capturing the flavor of native life in a coffee shop in Funchal, Madeira, was done in a flash with the built-in strobe.

avoid rickety ladders, step stools, and things of that nature. Now you're shooting down on the group at an angle, which spreads the light from the flash over the entire group, or at least over a larger number of people.

The next thing is to aim the camera one or two rows behind the front row—closer to the front than toward the back—and take the picture. If the crowd is really thick, you still might not get everyone perfectly exposed, but you'll certainly get more light on more people this way. Of course, this is not something you can do every time.

Another situation might be a ballroom, where you can climb up on stage to take the flash picture. You could have used this approach with

your friends at the fountain, if there were steps or a platform to stand on.

Avoiding red-eye

You've seen it — a person's pupil looks red instead of black, taking on that dreaded ghoulish look. For now, we'll simply say that it's caused by light entering the eye and reflecting off the retina at the back of the eye, back to the camera. The placement of the built-in flash and its close proximity to the lens makes it more likely to produce red-eye. The phenomenon becomes most severe when the pupils are wide open in low-light situations—that's also when a flash popping hurts your eyes the most. Flash manufacturers point out that children photographed under low light with

flash are especially prone to red-eye. Oddly enough, red-eye may affect one person and not another, or not to the same degree.

There are several very basic remedies. Use the special red-eye reduction mode if your camera has one. You can also turn on all the lights in the room. This constricts the pupils, making it harder for light to enter, bounce around, and come back out and into the lens. This may not get rid of red-eye entirely, but it should make it less prominent or lessen its intensity. Another possible remedy is to shoot from an angle above or below the subject's eyes. There are other approaches to overcoming red-eye that we'll encounter as we discuss using an accessory flash unit.

The Nature of Light

Electronic flash is a form of light, and as such, it shares certain characteristics with every other form of light. To varying degrees, we'll explore most of these characteristic features of light here. We'll introduce the concepts of exposure and contrast.

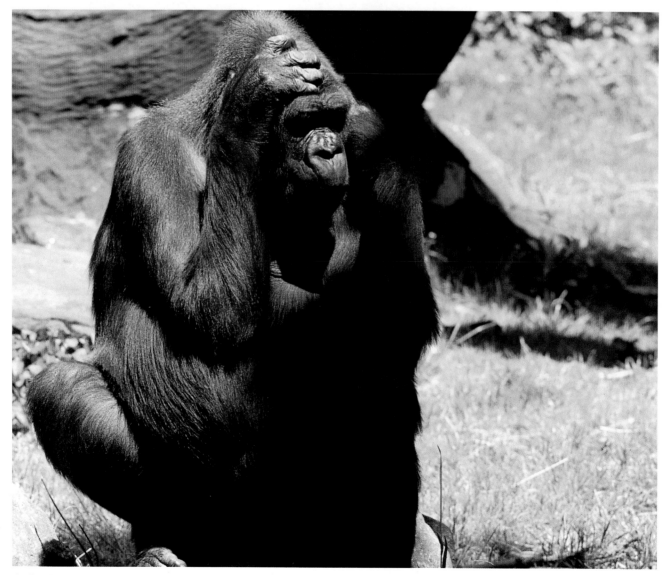

The bright sunlight produces harsh shadows that hide this gorilla's eyes from view.

Light has a measurable quantity, or level of intensity. When it's very bright outside, for example, there is a lot of light; on an overcast day, it is obvious that there is much less light in our environment. Exposure meters, such as those in cameras, have the ability to measure light quantity. However, not all exposure meters can measure light from the flash.

Light has direction. When the light shines in from the window or through the trees in a grove, that light creates shadows than run in the opposite direction from the light's source. The direction of the light is evident by the shadows, even if we don't see the source of the light directly.

Light has a definable quality. It can be hard or soft. Harsh light creates contrast and hard shadows. When there are no shadows or weak, indistinct shadows, this means that the light is too scattered and diffused (assuming it's not dark). In other words, the light does not have enough punch to produce a clearly defined shadow.

Light also has color. It's most obvious when we see a sunset or a neon sign, less obvious when we look at daylight or electronic flash illumination. The color of light will be discussed later, when we cover filters.

All this is true of any light source: sunlight, street or household lamps, or electronic flash.

Sunlight and Flash Compared

Hard light creates distinct shadows with crisp edges. Another characteristic of these shadows is that they are deep—or appear very dark. On film, these shadows hide detail and may appear as black. That's because our eye is capable of resolving more detail and differentiating between more shades of gray than film can image.

Bright sunlight, unobstructed by clouds or mist or fog, is at the heart of what we define as a hard light. It casts

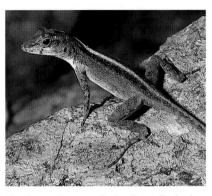

Similar to direct sunlight, direct flash also produces high-contrast lighting. Note the hard-edged shadows cast on the rock by this lizard.

very distinct shadows with a hard edge. The same can be said of flash when it shines on someone or something without anything to obstruct the path of the light it produces. The apparent difference between flash light and sunlight is the size and distance of each light source relative to our subject. Of course, with the sun as your light source, you can only control the relative distances of your subject and the background. You obviously aren't able to move the sun back and forth.

However, you can adjust the flash-to-subject distance, and a few feet closer or farther away will have an impact on the shadows created. When flash is used at a normal shooting distance from a subject close to and in front of a wall, shadows falling on the wall tend to mimic the subject in size, and are hard and deep. Move your subject away from the wall and the shadows soften.

Move the flash closer, and the shadow spreads out on the surface of the wall; the shadow's edges become less sharp and less black. The shadows begin to feather out at the farthest edges, softening to some degree. All this of course assumes that the subject and background remain at the same distance relative to each other and that only the light source—your strobe—is

moving closer. As the light moves farther and farther away, the shadows become increasingly hard-edged and solid.

Now if we keep the light source—the flash—at the same position but move the subject away from the wall and closer to the flash, we'll see that this will have the same effect as bringing the light source closer to the subject: This tends to lessen the intensity of the shadows falling on the wall, again softening the edges. Conversely, moving the subject right up against the wall, while keeping the light in the same position, will result in shadows that are very hard and intense.

If you'd like to try the above exercise, use a flashlight as your light source and a small object or your hand as your subject. Concentrate on seeing the effects. You don't need to shoot film or even look through the viewfinder of your camera.

Another exercise you can try uses a white card and a small object, perhaps a toy. Position the card so that it faces towards the sun. Place the toy between the sun and the card. Sunlight is reflected onto the side of the toy facing the card. Move the card closer to and farther away from the toy. You'll notice that the light falling on the toy is stronger as you bring the card closer, weaker as you move it back. So considering that this is reflected light from the sun, perhaps you can indeed move the sun—indirectly. The white card, like the moon which reflects sunlight back to earth, now becomes a secondary light source illuminating the shadow side of the subject. It's called a reflector. And in this case, it also serves as a fill light, or more accurately, a fill card. The original sunlight is still hard. Only now, we've reduced the contrast on one side relative to the other.

Available light vs. electronic flash

There are numerous situations that can be photographed by either available light or by flash. In some instances, flash clearly proves beneficial. In others, we might question the benefits and perhaps even point out where available light is the winner.

In each pair of slides, the photo at left was shot by available light, whereas the one at right was taken with electronic flash. The differences in some are subtle but worth noting.

These days, with electronic flash so readily available, we are often tempted to use it wherever we go. After reading the author's opinions, judge for yourself if these photographs benefited from the use of flash or if available light created the better picture.

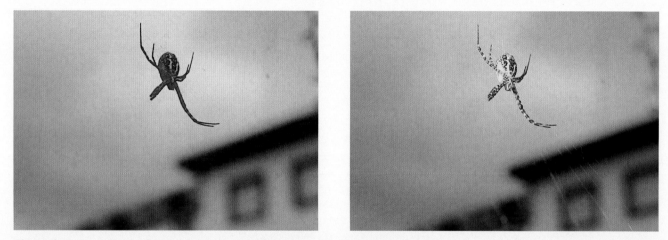

This spider on its web proved frustrating to photograph. It was positioned out of easy reach among a group of plants and poorly lit. Taking a sharp available-light picture proved difficult, and the backlighting made the spider a virtual silhouette (left). The flash image, using a ring-flash, properly illuminated the spider, creating the impression it was looming over the building beyond (right). Flash clearly was necessary here.

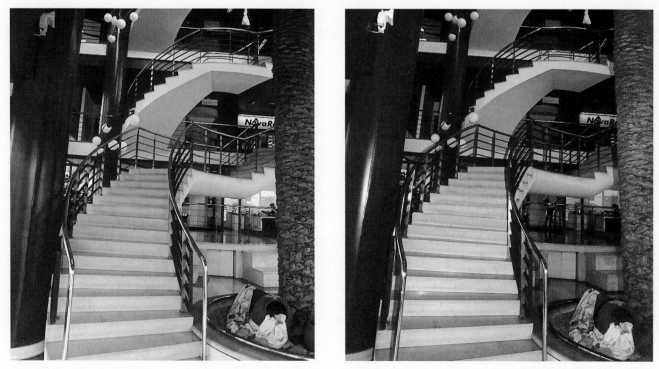

This shot inside an office building reveals the warmth of the colors by available light (left) but leaves us cold with flash (right). Also, note the shadow cast from the palm tree in the flash shot. No color correction filter was used to alter the results in either case.

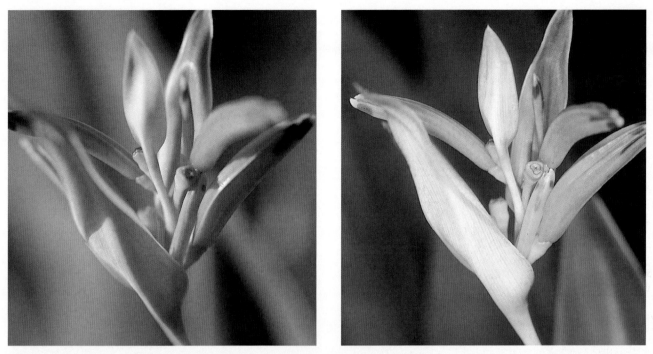

This flower close-up reveals how available light molded the petals through contrasts of light and shadow, although sharpness suffers owing to lack of adequate depth of field (left). The flash image, obviously with frontal flash, reduced the contrast and washed out the pale colors to such a degree that the flower looks somewhat lifeless, though sharper (right). Plants rarely place themselves in a convenient position to make using a tripod practical, so stopping down and shooting by available light was not considered. Even then, a breeze would have blurred the flower or thrown it out of focus. A better alternative would have been for the flash to be positioned off-camera, aimed obliquely down at the flower.

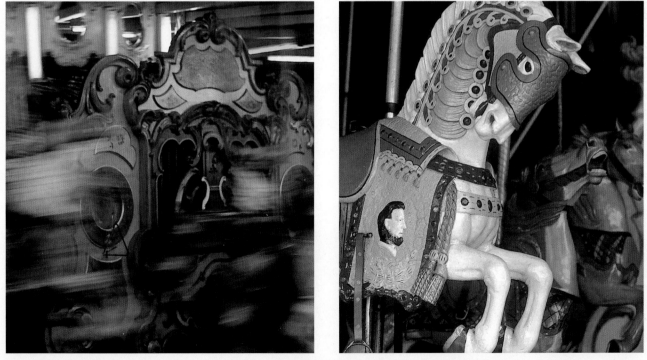

The blur resulting from the carousel's movement is interesting, but the green tint from the fluorescent illumination casts the ride in a disturbing light (left). Flash, on the other hand, captures this carousel horse at night with distinct clarity, without that greenish pall (right).

15

Diffused and Soft Light

When Punxsutawney Phil, the famous groundhog that predicts how much longer we'll be subjected to winter, sees his shadow, chances are that sky conditions are not totally overcast. Only very heavy cloud cover will eliminate shadows.

The difference is that the shadows produced under a light cloud cover are not as deep or harsh as those in bright or even hazy sunlight. As the light penetrates the clouds, it gets bounced around and strikes the earth in a pattern of oblique rays from different directions at the same time. To put it another way, the light is scattered and thus diffused.

Light emitted by an electronic flash is unwavering in its task: It heads straight for the subject. If you want to divert the path of those light rays, you need to plant obstacles, much as clouds become obstacles to sunlight. Since we can't just gather up a cloud and put it in a plastic bag to use as a light diffuser, we have to turn to special accessory devices to yield the same effect.

An alternative would be to divert the beam of flash light toward another surface, such as a ceiling or the white card we used earlier, which then scatters the light and sends most of it back in the direction of the subject at the same angle at which it struck the reflecting surface. We know this as bounce flash. Bounce flash is not a technique that we can use with a built-in flash. But keep it in mind for later, when you start to work with that accessory strobe.

When we later explore exposure and contrast, we'll see how the quality and intensity of light affect the subject and the way the subject records on film.

Fog reduces contrast considerably, as in this setting on Hurricane Ridge, Olympic Mountains, Washington.

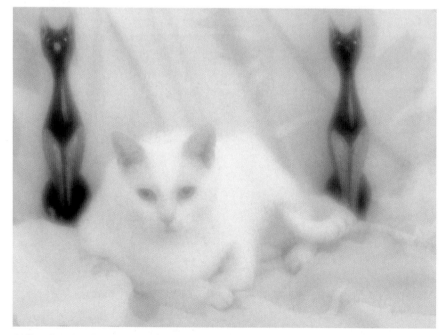

Diffused, umbrella lighting keeps contrast down while soft-focus enhances the effect in this portrait of the author's cat.

Frontal and Overhead Light

One of the recommendations given to beginners is to take pictures with the sun striking the subject from over your shoulder. This lighting is in essence frontal light. It may not be quite as direct as light coming from a built-in flash, but it is direct for all intents and purposes. It produces a flat effect, void of artistic or dramatic touches.

What is nice about frontal lighting is that it is clean and unfettered. It strikes the subject directly and evenly, and highlights all colors to their maximum brilliance. If we want to minimize the appearance of depth in a photograph or compress the scene, this flat lighting may actually prove beneficial.

We're also told to avoid shooting outdoors in sunlight between the hours of 10 AM and 2 PM. Here, too, the lighting produces unremarkable results that often leave the viewer unenthused. Shadows fall perpendicular to the subject, or nearly so, and that usually doesn't amount to a pretty picture. At least not with angular geometric forms, or facial features.

If we give overhead lighting the opportunity, we find it does have some redeeming characteristics. Put a globe on the ground under noon sunlight, and you'll observe a definite degree of shading on the sphere's lower half. The globe comes to life as a truly three-dimensional object. On the other hand, the same lighting angle on a person's face produces very unflattering results, with shadows that fall and intrude on important aspects of our physiognomy.

On the other hand, light directed upward, coming from below the chin is totally unnatural. It creates that ghoulish look we've all practiced at one time or another, by creating an unnatural pattern of light and shadow.

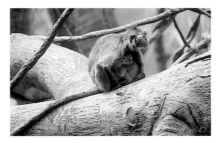

If viewed from above, everything in this scene at New York's Bronx Zoo would look flat. From the side, however, the overhead lighting adds shading and dimension to this setting. Moreover, the overhead sky-light is diffused enough in this instance so that, even in the shadow of its mother, the baby monkey is easily visible.

Frontal flash may provide a flat light but may still offer some contouring due to light falloff or even just a slight horizontal displacement, as with this plant shoot photographed on St. John Island, U.S. Virgin Islands. If this light was diffused, the edge along the right side would be softer and contrast would be lowered.

For this photograph the flash was positioned at an angle to add modeling and form to the young plant. Notice how changing the flash position has added dimension and texture.

Light strikes the trunk of this tree obliquely and molds the trunk into a three-dimensional form.

Sidelighting

Often the most picturesque and most dramatic form of lighting comes at the subject from the side at an oblique angle and accentuates texture and form. A relief map would look flat with frontal lighting, but when the light cuts across its surface at a glancing angle, suddenly every delicate aspect is brought to life. The shadows that form create contrast and help bring out, or relieve, the carvings. The same holds true with surface texture on a more subtle and finer scale. There is that same interplay of light and shadow, but it only becomes obvious when viewed close-up.

Achieving oblique lighting with flash in a way that fully brings out the necessary characteristics of the subject requires that the flash be removed from the camera. Shooting with flash on-camera and at an angle to the subject may make only the more pronounced facets of the subjects stand out in relief, creating an interplay of light and shadow that is unimpressive, at best.

Very dramatic sidelighting can have the effect of splitting a person in two—one lighted side and one shadow side. This happens when the lighting angle is extreme, hitting the subject at a 90-degree angle. This light can become a creative tool, leading to photographs with high drama that stand out from the crowd.

Backlighting and Rim Lighting

Light coming from behind the subject is illuminating the side that the camera doesn't see, leaving the side of the subject facing the camera in shadow. That can lead to some interesting pictures. In extreme cases, when the contrast resulting from backlighting is so severe, with the subject so deep in shadow, the result is a silhouette.

To achieve this effect with flash, it would have to come off the camera and be placed remotely, behind the subject. This obviously involves flash equipment that allows for a greater degree of flexibility. For now, let's practice creating silhouettes outdoors with available light. Later, we'll attempt them with flash.

What we're going to do requires a camera where you have some degree of exposure control. Point the lens at the bright sky—but never directly at the sun! Press down on the shutter button halfway to take the reading, and make your exposure based on this meter reading. Many cameras let you lock in the exposure simply by continuing to keep the shutter release button partially depressed. Others require that you press an auto-exposure-lock button to lock in the exposure settings. Either way, with that exposure locked in, recompose for the subject, and release the shutter to create the silhouette.

Backlighting lends itself to doing more than creating silhouettes. Light tends to catch on the outer rim of a surface and playfully bend around it, thereby highlighting that rim. This is known as rim lighting.

Aside from creating silhouettes and rim lighting, backlighting also serves a very basic function: It helps to separate the subject from the background, something on-camera flash often fails to do.

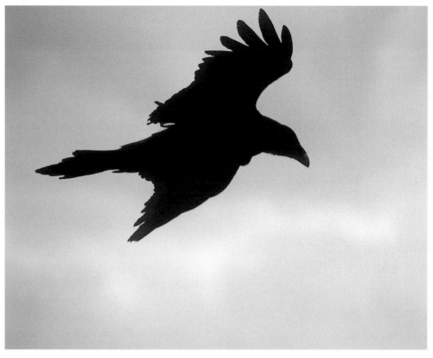

Here we see how strong natural light coming from behind this raven riding the thermals over Colorado's Rocky Mountains creates a silhouette.

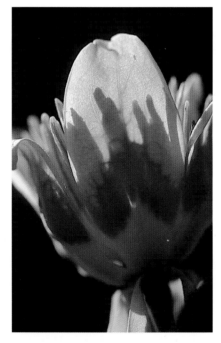

Light coming from behind this flower trans-illuminates its delicate petals while casting shadows from the opaque internal parts.

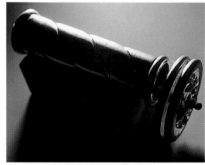

Light from an electronic flash placed behind this miniature kaleidoscope rim-lights the metallic tube and transilluminates the beads at the front.

Learn to recognize photos taken with direct, on-camera flash. Aside from red-eye that may occur in people and animals, there are other obvious and not-so-obvious telltale signs, as you'll see in these examples.

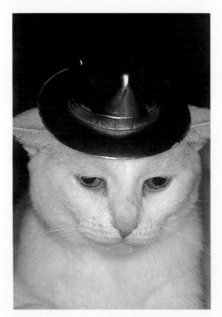

Owing to the angle, there are no catch-lights in the cat's eyes to betray the use of flash, but there is a hint of flash in the reflections in the plastic hat she is wearing.

On-camera flash produces a fairly flat light. Only the shadows hint of any spatial depth in these flowers.

Lighting With On-Camera Flash

There are certain aspects of on-camera flash that must be understood for you to use it to its best advantage and which will also guide you toward making more educated choices when it becomes necessary to take a different lighting approach. Some of these may have become apparent when you used the camera's built-in flash. Several others should catch your eye in any picture taken with a flash positioned on-camera.

Flat, hard lighting

For something to look three-dimensional, it requires a gradation in the shades of a color—what we normally refer to as the subject tones. When you place a flash on the camera, the light tends to hit the subject more or less head-on producing a flat, uncontoured rendering. For example, look at a person's face photographed with on-camera flash. You may see a hint of shadows in the face, but pay attention to the skin tones. Do they look fairly uniform from side to side? That's a result of flat lighting from on-camera flash.

This style of lighting has a hard edge to it. It makes subjects look stark. Should this quality of light be avoided? Not necessarily, many subjects benefit from this form of light. In some cases, this flat, hard light brings out the harsh realities of life. At other times, it's the only practical way to add extra light, such as at a party.

Harsh shadows behind the subject

What we readily see by ambient (existing) light, we overlook when it comes to flash. Because you can't see the shadows that form behind the subject when taking a flash picture does not mean they are not there. They are, and they're equally intrusive on the picture as when sunlight, for example, strikes the subject with the same effect.

When a dark shadow falls on the wall behind a person with dark hair or dark clothing, the dark tones tend to merge—they blend together, and it becomes difficult to discern where one begins and the other ends. By distancing the subject from the background, you won't have this problem, because the shadow will fall harmlessly away from the subject.

On the other hand, there are less obvious situations, such as a shadow from a beard falling on bare light skin or light clothing. The dark shadow merges with the dark beard, and in the picture it appears that the beard has grown in size. It might even take on comical proportions.

We can now extend the situation to where it's not the subject's shadow falling on the wall, but another shadow falling on the subject. A person closer to the camera may cast a shadow on the person behind. A tree branch may throw a shadow on that bird you're photographing. Or something may entirely block the flash so that all the strobe does is cast a shadow on the subject. In some instances, these shadows could lend an air of mystery to the picture—if that is what you want.

Avoiding glare

So what do you get when you shoot a reflective surface head-on with flash? Adding all that white light may wash out the ambient colors, for starters. The glaring reflections are often even more distracting.

A shiny surface behind the person being photographed reflects the on-camera light right back into the camera. That may create a large hot spot—a glaringly bright area that intrudes on the picture by drawing attention to itself. It can also wreak havoc, causing underexposure if it's really intense.

When photographing framed art work or other reflective surfaces with on-camera flash, similar hot spots manifest themselves, ruining the

Aside from producing a distinct shadow behind the rabbit, a head-on flash shot produced a hard reflection in the cabinet in back. In this case, it's not the subject that presents us with an objectionable reflection but the background.

The shadow is still there—after all, this still is direct, on-camera flash—but the glare off the wood is gone when we photograph the rabbit at an angle.

resulting image. Mirrors, smooth glass, and highly polished surfaces produce extreme glare. For that matter, you'll probably observe a patch of reflected white light in most things photograph-ed with on-camera flash when they sport a somewhat reflective surface.

What to do? We need an angle to get around the problem. If you're using on-camera or built-in flash, hold the camera at an angle to the window, mirror, or other shiny surface. The greater the angle, the more effective this remedy becomes—up to a point: too great an angle and you'll have trouble seeing the subject clearly. A 30- to 45-degree angle relative to the surface should prove satisfactory; anything less may not sufficiently reduce the glare. However, you can get better results if you have a connecting cord to take the flash off-camera. Then you can angle just the flash relative to the reflective surface and still photograph the subject from straight on.

With portraits of people, the flash might even create areas that appear washed out, most noticeably on the forehead and chin. Eyeglasses are another potential problem area for direct, on-camera flash: The light reflects off the lenses. Removing the glasses doesn't always work. For one, the eyeglasses may be a distinctive feature, without which the picture does not become a true portrait of that person. Equally important, taking the glasses off right before taking the picture may leave unsightly red marks on the bridge of the nose, which then must be touched up with makeup.

The viable solutions with on-camera flash involve shooting at an angle to the reflective surface. Turning or tilting the person's head or tipping the glasses slightly can largely, if not entirely, alleviate the problem. Another solution is to change the lighting by taking the picture from an angle other than straight on.

Bracketing is important when encountering tricky exposure situations, especially with a new camera. Photos of this scene were bracketed around a metered reading. The AEB (auto-exposure bracketing) function was used to produce the necessary series of exposures after the required bracketing increments were manually set. Here, bracketing was at +/- 1/2, with exposure compensation set to +1/2 to adjust for scene brightness. This series is as follows: normal metered exposure (top), +1/2 (center) and +1 (bottom). The metered exposure was too dark. The last two exposures are much better, although you could argue over which is best.

In each of these situations, the solution may not be the ideal one, but it will provide a more pleasing picture than with direct flash. To have more control over the lighting requires a flash that is more versatile, one which does not have to follow the camera. We'll need a flash that, while it may take its cues from the camera, can still move freely.

Basic Exposure and Contrast

Note: This discussion focuses on in-camera meters, although the basic principles apply equally to handheld meters, which may be mentioned in passing.

What does it mean to make a good exposure? It means that you've captured the desired tonal range on film that is important to you or to the person for whom that picture was taken. Exposure is one tool for the photographer to tell the picture's story, convey its message, or give the viewer visual information about the subject.

Exposure is a combination of film sensitivity and the intensity and duration of light hitting the film. Specific exposure controls include the film speed (ISO), the amount of light hitting the subject, the amount of light reaching the film, and time, namely, the shutter speed or for flash photography, the duration of the flash.

Exposure defines how light or dark an image will appear on film. It is directly tied into the film speed, which identifies a film emulsion's sensitivity to light. High-speed (fast) films—ISO 400 and above—are much more sensitive to light than low-speed (slow) films—ISO 64 and below. Medium-speed films—ISO 100 to 200—comprise the middle range.

Because film speed is the cornerstone of every exposure, the first thing required when loading film into the camera is to set the ISO. Thankfully, many of today's cameras can recognize DX coding and set the speed automatically.

How do you create a well-exposed picture? Today's cameras come equipped with sophisticated metering systems designed to do just that. The problem is that these meters, like the camera itself, are just tools. They need you to make certain decisions for them, to use your best judgment when something is right or wrong. Metering systems are programmed only up to a point, and they rely on you the rest of the way.

The first key point to understand is this: All meters are keyed to a gray tone—specifically an 18% gray, sometimes called neutral gray. An exposure meter reads and interprets the light as though it were being reflected off of an 18% gray subject. It is likely that a scene containing a predominant amount of dark or light tones will be incorrectly exposed unless the photographer intervenes.

For example, when photographing a white cat against a white wall on black-and-white film, the pictures will look as if a gray cat were photographed against a gray wall. In color the results simply look dark. The pictures were underexposed because the camera does not recognize that the subject was white, not gray. The camera's meter interpreted the subject the way it was designed to do, rendering everything no brighter than if it were neutral gray.

A KODAK Gray Card makes an excellent test target for exposure determination. It is this tone that the camera's exposure meter was designed to read in the first place. Position the card near the subject or in similar lighting and take a meter reading off of the card instead of the subject. Get in close to fill the camera viewfinder with the card, making sure not to cast any shadows on the area being measured. Also, make sure the card is not reflecting an excess amount

of light, which could throw the meter reading off considerably. Specific instructions come with the card, which is available at photo retailers.

The camera's meter is reading reflected light and basing exposure settings on the subject's reflectance. Now, think of the sensor as squinting when it sees a bright scene or straining to open its eyes as widely as possible to take in a contrasting dark setting. When squinting, the light sensor misinterprets the scene and tells the camera to end the exposure before enough light has reached the film to properly expose the bright scene. The result is underexposure. This has been defined by one photo writer as the squint factor.

When the meter reads a very dark-toned subject that reflects very little light, the camera sets the exposure to let additional light hit the film, thus rendering this dark scene as medium gray. This produces an overexposed photograph.

Your job, then, is to evaluate the situation and determine if exposure adjustment is necessary. How much? Admittedly, it is difficult to judge these situations, especially for a novice. While there is science behind exposure measurement, there is also a good deal of artistic judgment that enters the picture and every scene is different. That's why there are no absolute values to provide. One option is to meter off of a gray card, as mentioned.

Bracketing exposures is another possibility—taking several photos with incremental levels of exposure compensation to get one correct exposure. Most cameras and many dedicated flash units have user overrides which allow the photographer to set exposure compensation.

Exposing for the white cat/white wall situation, you can extrapolate the effect to arrive at the conclusion that more exposure is needed. Consider

adding 1 stop more exposure than the meter recommends and then bracketing the exposure in 1/2-stop increments. At +1 stop, the cat still looks too gray. Adding 1-1/2 stops brings back all the white without sacrificing tonal detail in the fur. If you add 2 full stops, the cat's fur is just a wash of white without any texture, because the film would not be able to resolve that subtle detail. It might be a true white, exactly what the eye sees, but on film it will record as a smooth surface. If it were a black cat against a black wall, then that would require less exposure. Follow the same basic procedure as with the white cat, but set the exposure so that less light reaches the film.

Camera Metering Systems

Advanced metering systems on many of today's cameras break up the viewfinder image into discrete segments and take the subject and background into consideration when determining an exposure. They may even bias the exposure to the subject in focus (targeted with the focusing sensor). These metering systems are referred to as *multi-pattern, evaluative, matrix, multi-segment,* or *honeycomb,* depending on the manufacturer. These or similar systems often play an important role in flash exposures in these cameras.

The stated benefit of these multi-pattern metering systems is that they more readily handle tricky exposure situations. They succeed most notably in situations where the main subject is positioned against a contrasting (brighter or darker) backdrop. They evaluate the various segments that comprise the viewfinder image, analyze the subject in focus, together with the background, and then expose for that subject, not the background.

However, when such metering systems encounter a scene with uniform brightness or uniform darkness, the potential for exposure error may still exist—and to the same degree as with other reflected-light readings. The recommendation, then, is to take the picture at the setting recommended by the camera, and another one with the necessary exposure compensation.

Center-weighted and *spot* metering are alternatives to multi-pattern metering. (Actually, they've been around much longer.) Center-weighted camera metering assumes that the critical exposure area centers around the central portion of the viewfinder image, and may extend downward. It's called center-weighted because the exposure is weighted, or biased, around this central area.

To some extent, center-weighted metering affords you greater control than multi-pattern exposure measurement. While no metering pattern is clearly mapped out in the viewfinder, it's possible to gain a good sense of what's happening here. The metering sensor places the strongest emphasis on the area at the center of the viewfinder. From there its sensitivity gradually diminishes outward, stronger toward the bottom than toward the top.

Consequently, center-weighted metering on many cameras assumes that you're shooting horizontal pictures with a bright sky in the top half of the picture. When the camera is used vertically, the center-weighted pattern does not ordinarily realign itself. The result is a slightly different exposure for the vertical image than for the horizontal picture.

Spot-weighted metering provides even tighter exposure control by focusing all the metering sensor's attention on one small spot in the center of the viewfinder image. This spot may not be clearly marked as such on the viewfinder screen, but fairly well overlaps the central focusing area in the viewfinder. More so than with other systems, here the sensor must point at the subject for spot metering to do any good. With that done, the picture is recomposed.

Spot metering relies on your ability to spot which tonality or brightness is important to the picture. It is that area which determines the exposure. You might use spot metering to bias the exposure to a key highlight for slide film, to an important shadow value for print film.

Understanding Contrast

Taking a correctly exposed picture involves more than merely judging if something is light or dark. A scene, even a singular subject, has contrasts of light and shadow. Parts are well-lit, other parts are not.

Photographic film doesn't necessarily deal well with excessive contrast. On a bright day, it has trouble seeing both what is fully lit and what is in shadow. It tries to capture all the detail but often can't. That's where exposure control comes in.

When you see a scene that holds too much contrast, you must meter for those areas of the picture that are most important to you. You may have to sacrifice the facade of that beautiful old mansion that is fully exposed to sunlight in order to capture the romantic couple sitting in the shade on the veranda. If the house is more important, then you might have to forego capturing the couple on film, leaving them to be enveloped by the darkness. This situation is an example of brightness contrast. We judge the relative brightness of each area of the

When contrast is relatively high, it makes correct exposure all the more critical. Highlight and shadow values might be lost if the scene were over- or underexposed, respectively, to an appreciable degree. If the contrast were higher, correct exposure would be even more demanding. Move in to a section of the scene in shadow, and suddenly you encounter a low-contrast setting, where everything is more or less uniformly lit and where exposure is less critical.

scene by how much light each area reflects (or in the case of light sources, by the intensity of the light emitted relative to darker portions of the scene).

Situations such as these were made for spot-weighted metering, and are often ably handled by multi-pattern metering as well. Of course, you might consider adding fill-flash for the couple, but that will come later.

There is another type of contrast that becomes important when you introduce your own lighting, especially when the subject demands both good highlight and shadow detail. This is called lighting contrast. Technically, it is a measure not of reflected light but of incident light. It comes into play when we more accurately try to determine the relative volume of

light reaching the subject as contributed by the main light and fill-light in a studio lighting situation, and is especially important with portraiture. Because determining this type of contrast is most readily achieved with a handheld meter, we'll leave this part of the discussion until later.

Flash Basics

Built-in flash may require little of us, but in return, it affords us minimal control. Accessory strobes are another matter. There are more buttons to push, choices to make, and steps to take so that the flash is in sync with you and the camera.

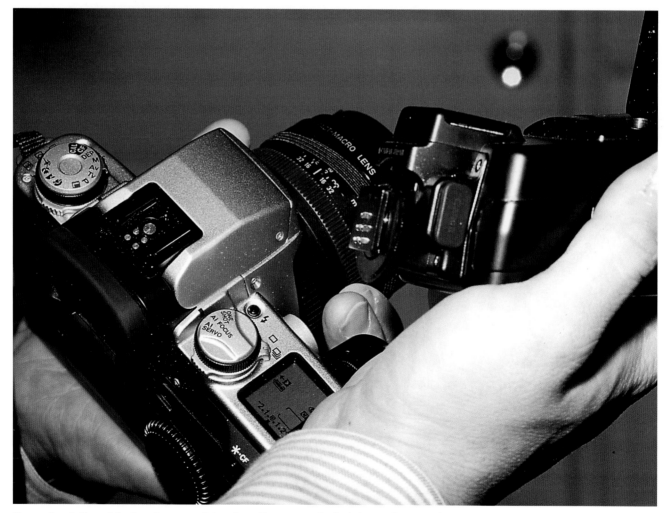

To attach a dedicated flash to the camera's hot shoe: Contacts on the flash foot and camera hot shoe must match for the components to interface fully and function properly. Insert the flash into the hot shoe so that the pins and contacts match. There may be an additional pin on the foot of the strobe, which moves into place to secure the flash when the knurled collar is rotated to the lock position.

Basic Settings and Preparations

If your 35mm SLR has a built-in flash, switching over to an accessory strobe requires that this little flash be retracted to its original position. Most cameras preclude the use of the built-in flash in conjunction with an accessory strobe. With that done, let's proceed.

For now we'll assume that the accessory flash is a shoe-mount unit designed to be seated in the camera's hot shoe. The hot shoe is normally positioned above the camera's viewfinder.

As with any battery-driven device, the use of an accessory strobe requires that fresh batteries be installed, and installed properly. Alkaline or rechargeable nickel-cadmium (NiCd) batteries are recommended. But never mix the two! Alkalines have a longer life overall, but nickel-cadmium cells recharge the flash faster from one exposure to the next.

Do not attach the flash to the camera yet. Switch the flash on and wait until the flash-ready indicator lights. If the indicator (also known as the ready light) fails to light within 30 seconds, it is often an indication that the batteries should be replaced (or nickel-cadmiums need charging). If that's the case, replace all batteries at the same time with fresh (or freshly charged) batteries. Be sure to keep a fresh set on hand for the next time. When the flash is not used for some time, it may take the energy storage capacitor a few moments to build up a charge.

Test-fire the flash with the test (or open flash) button to make sure the unit is in working order. Test the flash in a way that expends a full burst of energy. Usually that's done by setting the flash to manual mode at full power. This helps form, or condition, the capacitor. Turn the flash off before mounting to the camera.

No portable strobe is complete without the right batteries. Manufacturers generally recommend alkaline batteries or rechargeable nickel-cadmium cells. In addition, they may offer their own rechargeable battery packs. They do not ordinarily recommend using after-market battery packs, although others are available. Be forewarned that if you use batteries counter to the manufacturer's recommendations, it may void the warranty. While four AA alkaline batteries are the normal complement required by today's popular, battery-powered strobes, these batteries must be of the same type. Do not mix alkalines with rechargeables or other types of cells.

Next mount the flash on the camera, securely seating the flash foot—that square-shaped appendage on the bottom of the flash unit, normally with pins sticking out at the bottom—in the camera's hot shoe, making sure to push it all the way forward so that all metal surfaces on the bottom of the foot and on the hot shoe's surface make full contact. The pin (or pins) on the underside of the foot indicates the flash is hot shoe-compatible.

Most shoe-mount strobes also provide a knurled locking ring to secure the strobe in place. The flash will work regardless, but tightening the ring simply provides surer footing so that the flash won't accidentally slip off. To remove the flash, release the locking mechanism and slide the unit out of the shoe, until it clears the camera.

With the flash on-camera, set the camera to its simplest automatic operating mode, which for today's SLR often means program mode. Turn the

strobe on, set it to its automatic (sometimes called TTL) setting, and you should be able to start taking flash pictures right away. But don't just yet. A few things should first be made clear.

Note: If you haven't yet familiarized yourself with all the controls on the flash, take a few minutes to do so before going out to take flash pictures. While modern strobes make some operations easier, they also make other things more difficult, with a plethora of functions that must be understood for the flash to be utilized to its fullest capacity. Always keep the instruction manuals for your camera and flash handy. Undiscovered, or newly discovered, features can prove frustrating on these high-tech marvels without that guidance. Besides, even within one manufacturer's product line, from camera to camera and flash to flash, features change: What may work one way with one camera/flash combination may work another way with a different camera/flash combination, or may not work at all.

Dedicated Flash

A dedicated flash is one designed to link electronically to a specific camera model or camera system via the hot shoe, a connecting cord terminal, or, where applicable, by wireless sensor. A non-TTL dedicated flash uses its internal microcircuitry to communicate to the camera on the simplest level.

Today's more popular TTL dedicated strobes use microprocessors in the flash and camera to provide a two-way communications loop—automatically (user intervention optional), where each speaks to the other, back and forth. The degree of control this affords you ties directly into the degree of computerization in the flash and camera.

The most basic function of the hot shoe is to trigger the flash when the camera's shutter is released. A dedicated flash uses the hot shoe as a more advanced messaging conduit to the camera. Through various electrical contacts, information is passed between the flash and camera. Basic communications include signaling that the flash is charged and ready, and setting the appropriate shutter speed for flash synchronization. The detection of a switched-on, fully charged, dedicated flash connection immediately signals the camera that the flash unit is ready, willing, and able to perform on demand. At the same time, the camera signals in the viewfinder that the flash is charged and ready. Moreover, this same connection can automatically set the camera's shutter speed to the necessary flash sync setting. After the flash fires, and while the camera waits for a signal from the flash that it has fully recharged, the camera reverts back to ambient-light readings, switching back again when full-charge status in the flash is detected by the camera. This goes on no matter what exposure mode the camera is in.

All this and more applies at the next level of sophistication, TTL (through-the-lens) dedicated flash. A TTL flash sensor in the camera reads the light from the flash reflecting off the subject/scene after it comes through the lens. (Depending on the camera design, the light may first bounce off the film's surface or the shutter curtain before reaching the light sensor.) The camera's computer then signals the flash to end the exposure once enough light has reached the film for proper exposure. Flash durations of 1/20,000 second or shorter are not uncommon. This tells you how fast information is communicated between the camera and flash.

TTL dedicated flash systems have a sensor located at the film plane that measures light from the flash coming through the lens. The sensor sends a signal to cut off the flash when enough light has reached the film for proper exposure. The system is extremely adaptable to demanding flash situations, such as close-up photography and when using filters.

Autofocusing cameras take TTL flash metering a step further by establishing whether exposure will be appropriate for the subject and background together—not just the subject alone, providing a natural balance between the two. The camera's flash sensor, in combination with the ambient-light readings and focusing sensor, provides a full range of data that the camera's computer needs to calculate and control the fill-flash (flash-plus-ambient-light) exposure. (This description may be oversimplified, but unfortunately there are variations in equipment design and operation which may or may not take the focusing sensor into account, may or may not take distance information into account, and where the flash may or may not emit a pre-flash as a preliminary step in determining the flash-plus-ambient-light exposure.)

The dedicated flash attached to the corresponding camera works with the camera as a team, providing proper operation. Mount a flash dedicated to one camera line with an SLR outside that range and operation may prove erratic, particularly where TTL functioning is concerned. The mismatch may also damage the flash, camera, or both.

Generally, it's safest to stay within a product line. That's not to say that after-market flashes should be avoided. However, after-market flashes may not necessarily provide all the functions that the camera manufacturer's own dedicated flash units provide. To maintain dedication, after-market flashes are often modular in design to conform a single flash unit to the specifications of different camera manufacturers. Instead of a hot-shoe contact permanently attached to

the flash unit, this system uses a removable and replaceable module that slides or clips into place for direct attachment to the camera, on the hot shoe. (Where applicable, dedicated operation is maintained instead through a modular interface/sync cable.) The advantage to this type of system is that various cameras of totally incompatible design require only one flash unit with matching dedicated modules, instead of a separate flash for each. Because the individual modules are matched to the camera, providing a compatible interface, the flash may be used with some degree of assurance that it will work properly. However, camera manufacturers caution against using other strobes with their cameras, because there is the possibility that attaching another flash to the camera can result in damage, which may void the warranty. *Consult the manufacturer or your photo retailer for more details and compatibility.*

To get the most from any hot-shoe flash, make certain the contacts on the camera and flash are clean. A pencil eraser works to clean these contacts, but clear away the residue with a blower/brush. (Don't use the same brush on your lenses!) Operating the flash and camera under normal conditions should generally not necessitate cleaning. Keep the safety cap on the sync terminal when the terminal is not in use, and store the cap someplace where it won't get dirty or lost when it's not attached to the camera.

Note: Sync cords have a habit of getting misplaced, lost, or damaged. To avoid this: Always store them in the same spot in your camera bag, preferably next to the flash. As with electrical cords, don't tug on them by the wire. While all sync cords should be kept dry, electronic sync cords should be kept as free of dirt and dust as possible to provide proper contact.

Caution: Studio flash systems require higher triggering voltages than our everyday flashes. Professional and high-end amateur/semi-professional SLRs are often able to cope with these higher voltages. Dedicated cameras designed for amateurs may not be, even if PC adapters are available. *Consult the manufacturer before using a studio flash system with your camera.*

Flash Synchronization

Electronic flash must be synchronized to fire when the camera's first shutter curtain is fully opened, and before the second starts to close. The flash then fires, exposing the entire frame of film. The flash synchronization speed, sometimes called the x-sync speed, is the fastest shutter speed that can synchronize with the flash.

Flash sync speeds vary with camera and shutter design. Cameras featuring a horizontal-travel, rubberized cloth, focal-plane shutter normally sync at 1/60 second. Cameras with vertical-travel, bladed focal-plane shutters provide faster sync times, which can be as high as 1/125, 1/200, and even 1/250 second. These sync speeds are normally available to today's newer computer-driven cameras.

Virtually every modern, computer-assisted, 35mm focal-plane SLR camera manufactured today sets the flash synchronization speed—or simply flash sync—automatically, upon detecting a dedicated flash hookup, once the flash is turned on and fully charged. That, however, was not always the case, and numerous exceptions among non-computer-aided cameras exist even today.

The flash sync speed may be indicated by a color-coded setting on the shutter-speed dial.

Some cameras have a specific flash sync position on the shutter-speed dial, marked here with an X.

Today's electronic cameras may even move this function over to the mode dial, elevating x-sync to a special status.

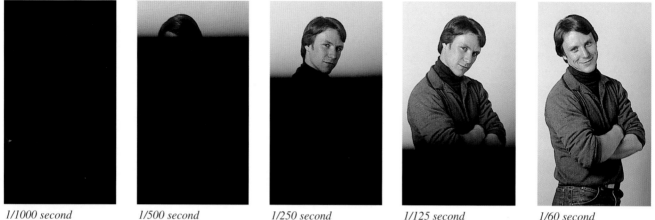

| 1/1000 second | 1/500 second | 1/250 second | 1/125 second | 1/60 second |

Cameras with focal-plane shutters have a maximum shutter speed—usually 1/60 or 1/125 second—that can be used for flash synchronization. Setting a faster shutter speed will result in only partial exposure of the image, as illustrated by this image sequence. Photos courtesy of Eastman Kodak Company.

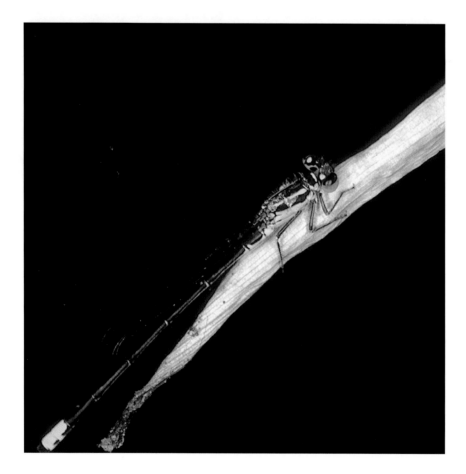

The combination of a small lens aperture and very fast flash sync speed prevents ambient light exposure. Flash isolates this damselfly and makes it stand out against a black (underexposed) background—even outdoors in bright sunlight.

Setting a shutter speed faster than the sync speed will result in only a portion of the film frame being exposed; the second shutter curtain will already be closing when the flash fires. The higher the shutter-speed setting, the worse the results. What happens if you reverse course, using longer shutter speeds? The ambient light may be strong enough to record on top of the flash exposure. This can cause unwanted ghosting or image blur. It also presents some very entertaining opportunities, allowing you to capture colorfully lit scenic backdrops or blurs of color by available light, together with a flash image of a foreground subject sharply portrayed in undistorted color.

High-speed sync

Some flash units provide the capability to sync at incredibly high speeds by way of a special feature, called FP (focal-plane) or high-speed sync. Instead of firing a single burst of flash which exposes the entire frame of film, FP sync uses a sequence of rapid, high-frequency flash pulses. These short bursts of light expose the film a little at a time as the shutter curtains move across the frame. When the flash is set to this mode, flash synchronization is possible even at the camera's fastest shutter speed. That can be as quick as 1/4000 or even 1/8000 second.

There are several situations when your photographs benefit from FP sync. By using a higher shutter speed with a larger aperture, you can thereby limit depth of field to a subject area you would like to highlight. This is known as selective focus. Also, to light a subject only with flash, FP sync can set a fast enough shutter speed to prevent any ambient light

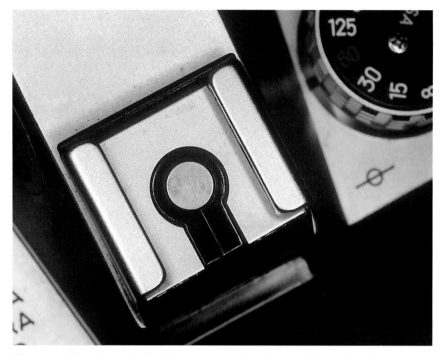

The camera's hot shoe is the first place we normally turn to establish a direct link between flash and camera.

A simple two-pin configuration of the hot shoe indicates a non-TTL dedicated relationship.

exposure, even in bright sunlight. In combination with a small aperture to limit the flash distance, a subject can be set off against a black (underexposed) background. FP sync can also be used to control fill-flash. The one drawback to using high-speed sync is that the higher the sync speed, the lower the flash's guide number, thereby reducing the effective flash range—the distance the light reaches.

Second-curtain sync

A popular trend in flash synchronization is second-curtain sync. Also known as rear-curtain sync, this delays the firing of the flash until the end of the exposure. Here, also, the camera has the opportunity to record an image by ambient light, but in this case, it's as a trailing blur behind the flash image. First- (or front-) curtain sync would, for example, create the impression that a dancer leaping through the air is moving backward, because the blur would precede, not follow, the flash-exposed image. Second-curtain sync produces a more natural effect with a blur of color behind the dancer.

Hot shoe vs. sync cord

When the flash is built-in, all the connections between flash and camera are internal and of no concern to the photographer. All that's needed is to activate the flash, if activation is not automatic. However, for the camera to trigger an accessory flash directly, there must be some physical linkage between the two.

Most 35mm SLRs provide that physical connection by way of the camera's hot shoe. The shoe contains electrical or electronic contacts which, like anything carrying current or volt-

age, are called hot. The flash foot—the bottom-most part of the flash—has matching contacts, in the form of pins, on the underside of the foot.

Non-shoe-mount strobes and shoe-mounts used off-camera are attached to the camera by way of a sync cord. Using a sync cord bypasses the hot-shoe contact. Today, with the popularity of hot-shoe flashes, we often tend to overlook our reliance on a sync cord and sync terminal. It is this sync cord that, in part, leads to some of the most fascinating flash images by freeing the strobe from the physical confines of the camera.

Some inexpensive flashes come with a sync cord permanently attached. It's preferable that the sync cord be separate. These cords are easily replaceable, but if one that is permanently attached to the strobe gets damaged, it will need a factory repair.

The sync cord is connected to the flash at one end and to a sync terminal (or outlet) on the camera at the other end. The simplest, most universal sync cord is called a PC cord. The simplest sync connection is also referred to as a PC terminal when designed to accept a PC cord.

In order for today's electronic SLRs to operate in conjunction with a TTL dedicated strobe off-camera, they require a dedicated electronic cable. This then connects to a computer-style interface—a terminal configured differently from the standard PC socket—on the camera body. A plastic cap normally protects this terminal.

If this cable looks nothing like the old PC cord, that's because it is more akin to a computer cable. Such electronic dedication, however, may mean that a conventional, non-dedicated strobe is not usable together with a

camera requiring a dedicated hookup. An adapter may be required (if available) to attach the non-dedicated strobe to the camera.

On the other hand, the same camera may indeed provide a standard PC terminal for conventional flash operation—that is, one that entirely bypasses the camera's computer brain and the associated high-tech interface to the flash. The photographer will find this a useful feature of even the most automated cameras when using non-dedicated handlemounts or off-camera shoe-mounts, and studio flash units.

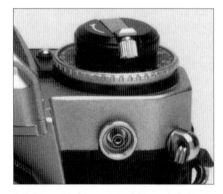

A PC terminal is required for non-dedicated flash operation via a sync cord. Photo courtesy of Silver Pixel Press.

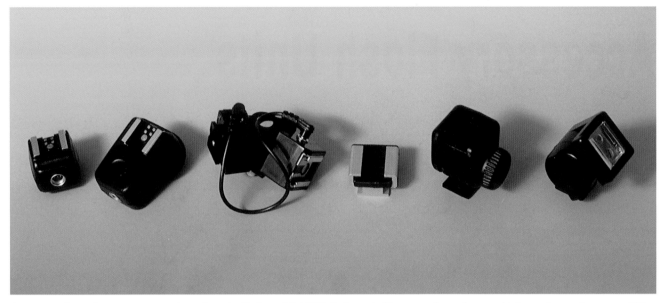

Accessory shoe adapters meet a variety of needs. (Left to right) TTL dedicated off-camera shoe adapter, which attaches to the remote TTL strobe and connects to the TTL sync cord via the terminal (shown) for use either singly off-camera or in a multiple TTL flash setup; TTL hot-shoe adapter that sits on the camera's hot shoe and to which all remote strobes are connected; tilt-swivel hot-shoe adapter for conventional, single-pin hot-shoe strobes lacking the bounce feature; off-camera shoe adapter suitable for hot-shoe strobes—plastic at the base where the strobe contacts fit into the adapter prevents the strobe from shorting out; tilting on/off-camera shoe adapter also suitable for hot-shoe strobes; and tilting on/off-camera shoe adapter with metal plate for non-hot-shoe strobes only.

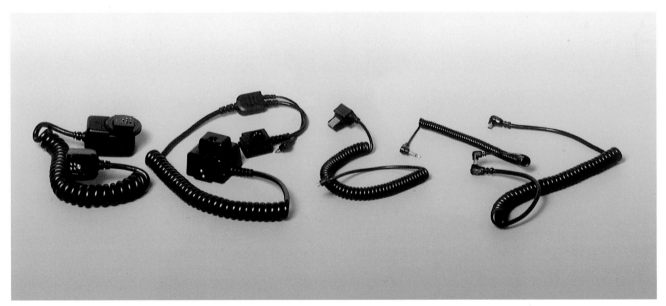

(Left to right) TTL dedicated remote sync cord, dedicated non-TTL remote cord with removable auto-sensor, non-dedicated PC/sync cord for a strobe capable of TTL flash with the appropriate module, and a more conventional PC/sync cord attached to a PC extension cord.

Accessory Flash Units

The flash units discussed here are portable strobes. Studio-type accessory flash will be covered further on in the book.

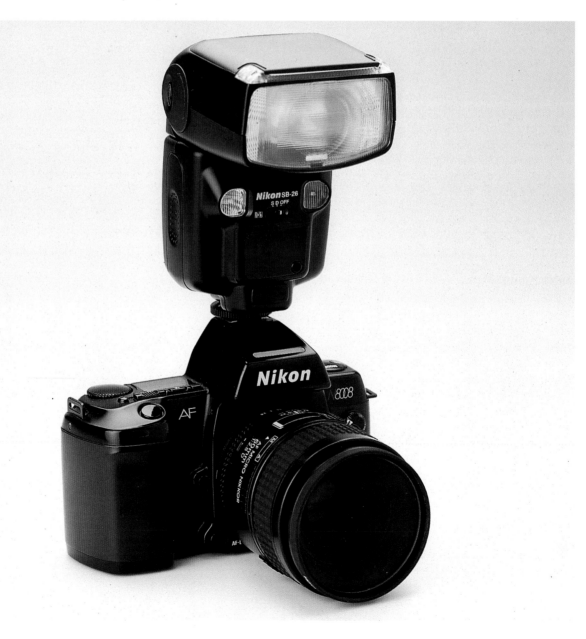

Often the type of accessory flash we use determines our working style. A small, shoe-mount flash on the camera's hot shoe gives you great maneuverability. You can zip in and out of crowds almost as easily as with a built-in flash, but with more power at hand. And features—there seems to be no limit these days. Generally, a handlemount strobe is a powerhouse of light, with unmatched versatility in many respects. Its larger size may seem unwieldy at first and take some getting used to, but it's the right choice when a great deal of flash power is needed.

Note: From this point forward, an SLR is recommended so that you can take advantage of the various types of equipment and techniques discussed. Use of an accessory flash with point-and-shoot cameras is rarely an option. Further, while it's assumed that the SLR you're using is a 35mm design, an Advanced Photo System SLR can be used, so long as it accepts an accessory strobe.

While today's shoe-mount strobes are microprocessor-controlled, they still rely on time-proven technologies, such as a flash tube to serve as the light source and a capacitor to store the charge the strobe needs to trigger the flash. Photo courtesy of Canon U.S.A., Inc.

Shoe-Mount Flash

Next to that little built-in flash, shoe-mount flash is the most popular and most readily available form of electronic flash in use today. As its name implies, this light sits on the camera's accessory shoe, generally found atop the camera, above the prism.

The shoe-mount strobe, sometimes called a clip-on flash, is a combination power module and light head in one. It holds the batteries from which the unit draws its power, in a special compartment in the lower section, and provides those instantaneous bursts of light from the head of the unit housing the flash tube. The batteries feed the internal energy storage capacitor, which builds up the charge needed by the flash to generate those bursts of light. Mixed in with all that is a complex network of wires and solid-state

The tilting head found on many flash units makes it convenient to bounce the light. The flash unit can remain in the camera's hot shoe, therefore no additional connecting cord is required. Photo courtesy of Eastman Kodak Company.

circuitry. With TTL dedicated systems, the CPU in the camera, working with its less-advanced counterpart in the strobe, is the brain that dictates how much light to produce after it receives data from the user, the flash, and its own light sensor.

The flash head is often designed to tilt and may also swivel about its axis. Both movements are intended for creative uses, mainly bounce flash. Click stops hold the tilt or swivel position. The flash head may tilt upwards as much as 90 degrees. This is useful when mounting special bounce-flash accessories on the flash head. Many flash heads also have a slight downward tilt allowing the light to be directed at close subjects.

The face of the flash houses the auto-sensor for conventional automatic (auto-sensor) flash mode. Not all shoe-mount flashes feature an auto-sensor or an auto-sensor mode. Manual-only strobes most notably do not have automatic capability, but select TTL strobes may lack the auto-sensor function as well and are therefore unable to provide non-TTL automatic operation.

One key feature found on strobes designed for autofocusing cameras is the AF-assist beam. Easily recognized by the red plastic cover protecting it, this feature aids the camera in determining the subject distance for proper exposure. As with the AF-assist beam on the camera, the range is limited to within about 30 feet, more or less (varying with design). The camera's programming determines which autofocus beam—the one on-camera or on the flash—will activate in various on- and off-camera flash applications.

The back of the flash is where all the controls lie, but this is also where you find the information display, often a flash calculator or digital panel. Underneath, or surrounding, the display is an array of buttons or switches, including the on/off switch, flash-ready signal (or ready light), and flash-confirmation indicator.

The flash-ready signal tells you the flash capacitor has reached a full charge. This may also serve as the test, or open-flash, button that is used to pop the strobe independently of the camera, without making an exposure, or when the shutter is set for time exposures. With auto-sensor flash, the open-flash button helps you determine if the subject is within the flash range for the *f*-stop selected, coupled with the flash-confirmation signal. When, as on some strobes, the flash-ready and flash-confirmation signals share one indicator, the light may blink to indicate an incorrect exposure.

Shoe-mount strobes routinely feature all the controls on back. Conventional auto-sensor strobes provide an auto-aperture/manual mode selection switch, flash calculator, lighted flash-ready and confirmation indicators, and in some cases, a power ratio control.

Digital shoe-mount flash units often are packed with features accessible by way of the function buttons on the back panel. The LCD panel is the most prominent feature.

The mode button or switch lets you choose from the exposure modes offered by the flash unit. TTL auto flash, auto-sensor flash, manual, and perhaps options such as stroboscopic mode may be selections on the mode switch depending on the design. Simpler flashes have fewer options.

TTL auto flash, manual flash, and stroboscopic modes may make use of other buttons that define the extent of control available. TTL auto might let you set flash exposure compensation (useful when this feature is lacking on the camera), manual mode could offer power ratios, and stroboscopic opera-

tion lets you set the number of consecutive pulses and their intensity. Another button may control the zoom setting, for automatic operation or manual override. Yet another switch may set the flash to fire in conjunction with first- or second-curtain sync, although this may be a function of the camera (depending on design).

Note: With many flash units, the flash-ready signal may light to indicate a usable charge capacity has been reached, even though the flash may only have reached a partial charge. For a brief moment, the unit may continue to emanate an audible high-pitched whine or hum (more easily detected in some strobes than in others) as an indication that it is continuing to charge to full capacity. On average, this partial charge reflects decreased flash output by between 1/3 to 1/2 stop. This could especially affect manual flash exposures and should be considered when making the exposure. As a result, it pays to allow another moment to pass before firing the strobe, to achieve the fullest output possible in any flash mode. Some strobes may actually provide a partial-charge status indication, which changes accordingly to show when a full charge has been achieved.

Caution: Cameras should never be carried by gripping a shoe-mount strobe that is seated in the hot shoe. The flash foot and camera hot shoe were not designed for such excessive stresses.

Handlemount strobes may have a flash calculator on top of the unit, which in this case also controls manual power ratios (photo top). Other functions, such as indicator lights, are located on the rear of the flash unit.

Flash functions are set on the advanced Metz 50 MZ 5 (photo left) using a control unit, which mounts in the camera's hot shoe. Photo courtesy of Metz-Werke GmbH.

Handlemount Flash

Attaching a shoe-mount strobe to a flash bracket does not make it a handlemount. A true handlemount strobe comes equipped with its own handgrip attached to the flash head. These units establish a linkup to the camera by way of a sync or connecting cord. A mounting bracket for the camera and flash is often supplied or available as an accessory. The bracket attaches to the flash unit's handgrip and to the camera at the tripod socket. When it becomes necessary to carry the camera with one hand, this should be done holding the grip handle, not the camera. It's wisest and safest to support the camera with your free hand.

Designs vary, but many of these strobes pack all the necessary flash modes: TTL auto, non-TTL (auto-sensor) automatic, and manual. The more advanced handlemounts share many of the advanced features of the shoe-mount, offering one or two refinements of their own.

A handlemount looks different from a shoe-mount. It feels different. To some extent, it acts differently. The handlemount strobe is often the heavyweight, in all respects, in a manufacturer's lineup of portable flash equipment. That may mean it carries the highest guide number, making it the most powerful strobe in the line-up. It almost invariably features a tilt-and-swivel head. If perceptions count for anything, it looks professional.

The twin-head handlemount

Whoever said two heads are better than one wasn't kidding. Bounce flash can create pockets of shadow in the eye sockets and elsewhere on the face. Also, bounce flash won't add catchlights in the eyes, therefore they will appear flat and lifeless. The presence of catchlights adds a look of vitality. Of course, the subject's posture, attitude, and facial expression have much to do with the overall impression conveyed in the picture.

A select few handlemounts give you not one flash head but two. (This may also apply to some shoe-mounts.) The second head, located below the main head, is activated by its own on/off switch. When the main head is tilted upward, the secondary head—or sub-flash—remains in a fixed forward position. It acts as a fill light for the main flash head and adds a catchlight to the eyes.

The way the sub-flash works is this: Activating it shunts a small portion of the overall power away from the main head to this smaller head. This secondary head's minimal output provides that it does not overpower the main light. However, that possibility still exists if the main light is sufficiently weakened upon reaching the subject. Sometimes bounce flash can take a lot out of the main light, perhaps enough even to give the lesser flash tube the appearance of being stronger than it really is, to the point where it may create a secondary shadow. Using a neutral-density filter over the secondary flash will reduce the light output in these situations.

This handlemount strobe comes with a variety of options. The primary head tilts and swivels and a secondary sub-flash provides fill when the primary head is used for bounce lighting. The handle is a permanent feature, which mounts to a detachable bracket. The wide panel and neutral density filter for main and sub-flash are included with this model. Other available accessories include a filter kit and rechargeable battery pack.

Built-in versatility

A rare number of handlemounts offer interchangeable flash heads. Accessory flash heads serve a special purpose. One type is called a barebulb head. This head has no reflector to concentrate its beam of light in one direction, so the light radiates outward in all directions, just like a light bulb screwed into a lamp but without a shade. Some photographers use barebulb flash outdoors on an overcast day or in the shade to simulate hazy sunlight. Other times they may use it for greater flash coverage, especially with a fisheye or ultra-wide-angle lens on the camera. Barebulb flash produces a hard yet at the same time diffuse light, with distinct shadows that are not excessively hard-edged. Another head is a zoom head, which is useful on strobes that did not provide this function out of the box.

Caution: Every strobe can fire once its capacitors have formed a charge, either full or partial. However, the flash can fire only so many times before it overloads. This limit is governed by the duty cycle. Handlemount strobes generally have a higher duty cycle—they can fire more times in sequence—than a shoe-mount (even one with the same guide number)

before reaching the breaking point and failing. Yet it may only take a handful of rapid-succession flashes at full power, or two or three times that at partial output, to burn the unit out so be careful, especially with smaller, non-professional flash units.

Off-Camera Flash

At the very least, off-camera flash gives you additional control over how a subject is lighted. Aside from that, a flash positioned off-camera offers new and challenging levels of creativity.

- You can bring the flash closer to the subject or move it farther away.
- You can use accessories designed to produce very pleasing and often professional results with off-camera flash.
- You can use flash units other than those designed to fit in the camera's hot shoe, such as handle-mounts and studio strobes.
- You can use more than one flash unit to illuminate a scene.

What do you need?

- Sync cord. To operate your hot-shoe flash off-camera, you'll need a sync cord of some kind, one that matches the intended exposure applications of flash and camera. In other words, to maintain the features of a dedicated flash requires a dedicated sync cord or module. Non-dedicated operation, auto-sensor, and manual flash modes need only a standard sync cord.
- Extension sync cord. Sync cords are usually too short to allow a flash to be placed more than a few inches from the camera. An extension sync cord, like an electrical extension cord, gives you greater leeway in positioning the light. TTL strobes instead require a longer dedicated cord (available separately) than the standard off-camera cord to maintain TTL dedicated operation at greater distances from the camera.
- A slave sensor or remote-triggering device. (These will be discussed in detail at a later time.)
- Flash bracket. You can't stand there holding the off-camera flash in one hand, the camera in the other all night long, although some people will do just that. To make the camera/strobe combination more manageable, use a bracket which attaches to the strobe and camera. Some brackets are very simple and compact, even folding to fit easily in a pocket. Others are more elaborate, with additional features and accessories available. Special brackets—those used by professional photographers in particular—raise the flash above the camera, preventing harsh shadows and red-eye.
- Light stand (or tripod). More creative lighting opportunities become available when you remove the flash completely from the camera. With the flash unit mounted on a light stand (a tripod can be used, as well), you are then free to move around while the flash remains stationary, until you decide to move it. Make sure the flash will attach to the light stand (or tripod)—an adapter may be necessary.

Using a flash bracket can have many advantages. The flash is placed high over the lens for more pleasing lighting—harsh shadows and red-eye are eliminated. The Stroboframe® Pro-T bracket has a rotating flash arm that allows the flash to be positioned over the lens when the camera is turned to the vertical position.

Different types of brackets exist to handle a variety of needs. This bracket features a stocky handle to hold a rechargeable battery pack. Contacts on the front of the strobe plug into the rear of the handle. The flash is shown with the removable auto-sensor positioned on the camera to provide more accurate auto-flash readings while the strobe sits on the bracket.

Electronic Flash Control

Today's advanced dedicated flash systems are incredibly automated and user-friendly. However, understanding electronic flash functions and limitations will help you utilize your equipment to the fullest for better flash photographs. We begin slowly, by exploring relationships of lens aperture, shooting distance, and film speed and go on to discover various ways to control flash output to meet the needs of the subject. The pace quickens in later sections of the book as you move beyond the basics into truly creative control.

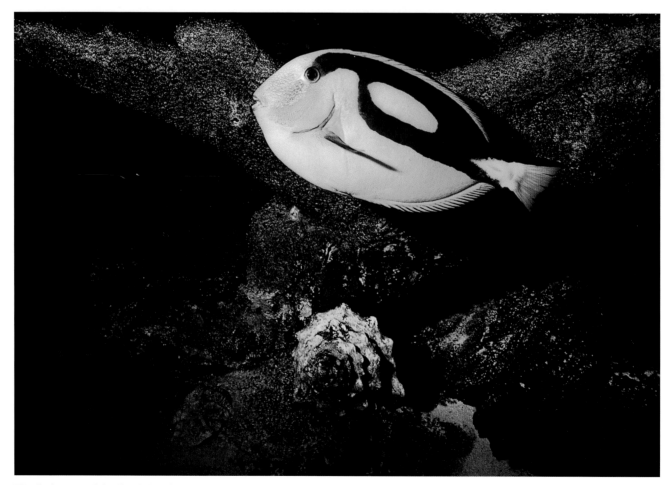

The flash exposed this brightly colored fish perfectly but didn't have the range to illuminate the rocks at the back of the aquarium.

The Basics of Flash Exposure Control

Our earlier discussion of exposure focused on ambient light. The same basic exposure principles hold true for flash exposure. The important thing to remember is the combination of factors that dictate flash exposure: subject and scene reflectance, subject distance from the flash, film speed, the amount of light output by the flash, and aperture setting on the camera. The two exposure variables most easily controlled by the photographer are the *f*-stop and flash-to-subject distance.

Note: When we refer to subject distance in all these discussions, it actually refers to flash-to-subject distance, unless otherwise noted.

Distance and aperture

When we photograph with available light, subject distance is a concern only in regard to focusing and composition; it has no bearing on the amount of light that reaches the film, and therefore does not affect the lens opening or shutter settings.

In flash photography, subject distance, or more accurately, flash-to-subject distance, is a much more significant factor. Distance must always be considered when taking flash pictures because light diminishes in intensity the farther it travels from its source. The burst of light generated by the flash unit immediately begins to spread out as it leaves the flash tube. The farther it travels, the more it spreads out, reducing its intensity. When the subject is near the flash, the light has not spread out very much and is therefore very bright; in fact under some circumstances, it may be too bright. Conversely, a distant subject will receive much dimmer light from the same flash. The farther the subject is from the flash, the larger the aperture needs to be to allow more light to reach the film.

F-stop and flash-to-subject distance are directly related. This series was shot in Funchal, Madeira, outside one of the city's many mini-banana plantations. The camera's built-in TTL auto flash was used with an 85mm lens. Shooting distances varied as follows: 3 feet (photo top), 8 feet (middle), and 15 feet (bottom). All exposures were made in program mode at 1/60 second and f/2.8 on ISO 50 film. No exposure compensation was used. Note how exposure was fairly uniform for the first two images, but 15 feet was a stretch and decidedly led to underexposure. Distance values are approximate.

As a consequence of this, when the flash is set on manual, you must set the lens to an aperture appropriate for the light level found at each flash-to-subject distance. With automatic flash, each lens aperture automatically produces correctly exposed flash pictures, but only over a prescribed range of distances. As you change apertures, the near and far limits of that range shift. While this may sound somewhat complicated, it is extremely easy in practice. In most cases, all necessary information is right on the flash, and absolutely no calculations are required.

Here is a mnemonic to help you remember how this *f*-stop/distance relationship works:

Large *f*-stop = Long reach: The larger the lens aperture, the longer the throw of light; to be used with subjects farther away from the camera/flash.

Small *f*-stop = Short reach: The smaller the lens aperture, the shorter the throw of light; to be used with subjects nearer the camera/flash.

Flash exposure calculator

The flash exposure calculator, usually a dial or linear sliding scale, is a familiar feature for determining the appropriate aperture/subject distance on auto-sensor strobes. It is also useful when operating an automatic strobe in manual mode. The exposure calculator consists of several user-adjustable settings. First, you have to set the film speed index. The aperture is then selected and checked against a graphic display for distance. Another setting that may be required tells the flash that the wide or telephoto panel is in place. Select flash units make this adjustment automatically for the wide panel when it is attached.

The latest incarnation of the flash exposure calculator is the digital LCD (liquid crystal display) panel on TTL dedicated strobes. It presents all the

applicable data in a manner that's readily usable. Unlike the analog dials and scales, most settings and calculations are done automatically. Typical digital panel information includes flash mode, zoom setting, film speed, and flash range for the set aperture. The drawback to this display may be that it goes blank to conserve battery power, unless you hold the shutter button down halfway to maintain activation.

Putting the flash exposure calculator to use: Say you're shooting ISO 100 film, your subject is 30 feet away, and you'd like to use a small *f*-stop for greater depth of field, let's say *f*/11. The exposure dial or digital display on the flash tells us that this *f*-stop will not be sufficient. If there is no available means to add more light or load faster film, the only option is to use a large *f*-stop to expose for the subject 30 feet away. The calculator shows that *f*/2.8 is required to throw light out 30 feet, so we set the lens aperture to *f*/2.8, instead of *f*/11.

Unfortunately you've had to compromise the depth of field. To use a smaller aperture, the flash would have to be brought closer to the subject. If you moved the flash to 7.5 feet from the subject, referring to the flash calculator would show that *f*/11 will indeed cover this new distance.

Film speed

Aside from the inherent grain and contrast characteristics of the film, there are specific reasons to use fast and slow films with flash. A slow film is normally associated with bright, well-lighted situations and generally, slower shutter speeds and larger apertures are needed. Fast films are chosen in low-light situations and when fast shutter speeds or small apertures are desired.

Twist a couple of dials on the flash calculator to arrive at the necessary f-stop and distance data.

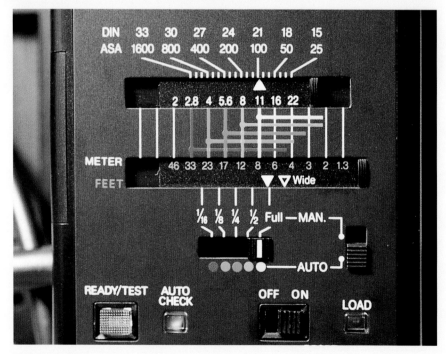

This linear flash calculator works the same way as the dial but may be less familiar.

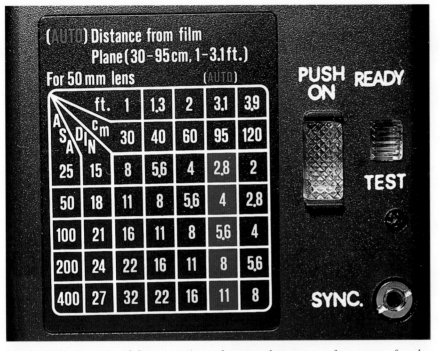

Match numbers across and down to arrive at the proper lens aperture for a range of working distances. If the range of distances appear restricted, it's because this table comes from a macro ring-flash, which is designed only for working at close subject distances.

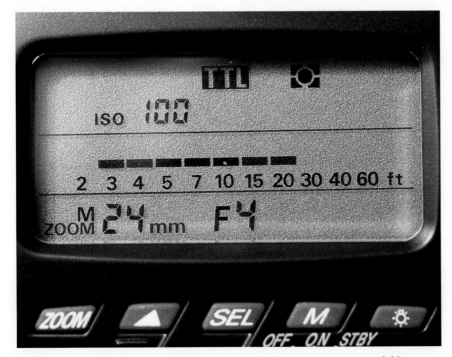

Digital shoe-mounts provide a virtual cornucopia of information in a very readable manner. No dials or sliders to move around, no tables to mull over—but there are buttons to help you make the necessary selections.

When shooting with flash, the reasons for choosing a particular film speed differ slightly. Aperture is still a factor. Shutter speed has no effect on flash exposure and is of no practical concern. It is replaced by flash-to-subject distance, the second critical factor in flash exposure.

Until now we've assumed a basic ISO setting of 100. Obviously, there are faster and slower films. Just as film speed affects the combination of *f*-stop and shutter speed in an ambient-light exposure, it affects *f*-stop and flash-to-subject distance in a flash exposure. To increase the throw of light, especially with a strobe that is not very powerful, a fast film might be required. The alternative would be to use a fast lens with a larger maximum aperture than the current lens can provide. A slower film, on the other hand, would help to tame the light, allowing for shorter flash-to-subject distance. As we've already seen, a smaller *f*-stop would provide similar results.

Guide number

The light output of a built-in or accessory flash is expressed as a value called the guide number (abbreviated GN). That's true whether the strobe is computer-governed TTL flash, conventional automatic, or manually controlled. The *f*-stop and flash-to-subject distance needed for proper exposure are determined from the guide number. Although photographers don't need to calculate exposure anymore, it is still useful to know a flash unit's guide number.

The guide number specifies the light output at a particular film speed and focal length setting (only if the flash has a zoom head). Based on the guide number, the aperture and flash-to-subject distance needed for correct

The auto-zoom feature on a TTL dedicated strobe sets a zoom position on the flash head commensurate with focal-length data electronically received by the camera when a lens is mounted. As you can see from these digital displays, for a given f-stop, the effective maximum flash-to-subject distance varies with the zoom position. At the 24mm setting, the flash range is 2.5 feet to 25 feet, while the 85mm setting gives a range 4.5 feet to 50 feet.

exposure can be calculated. Stated simply and succinctly, the guide number tells us how far the light will reach at a specified lens aperture and at a given film speed.

Variables that affect the guide number are the film speed and coverage of the flash. The GN is always stated in relation to a film speed, usually ISO 100, for distances measured in either feet or meters. The value provided is for a specific focal length—more correctly, the flash coverage for that focal length. Zoom flashes may specify a range of guide numbers over the range of focal lengths covered by the zoom head. A 50mm lens (on a 35mm camera) is the most common, but it varies from flash to flash. Accessories that attach over the flash head, such as a wide-angle diffuser, will modify the guide number rating.

While we may look to the guide number to learn what we can expect from a strobe at, say, a certain film speed or lens aperture, we also look at the GN value when we have to choose from among several different flash units that we're considering buying or using. It might be important for us to have a powerful strobe to meet a wide range of shooting conditions with subjects near and far. We then look for a high GN rating. The guide number does not necessarily reflect how fancy the strobe is in terms of features or electronic control, or how fast a flash will recycle after it's fired. It's simply a measure of output. It reflects the capability of the unit right out of the box, without any fancy accouterments thrown in.

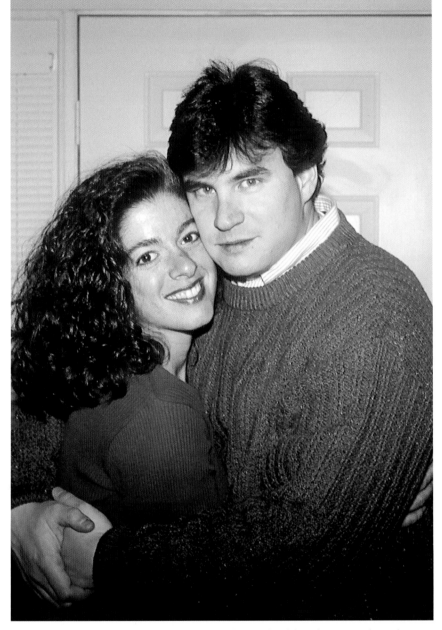

Manually overriding the auto-zoom setting to a longer focal-length position than what is needed for a specific lens may result in incomplete light coverage. While not terribly objectionable in this case, it is still distracting. Had a wider lens been used, vignetting would have been more pronounced. As is apparent here, vignetting does not necessarily occur uniformly around the perimeter of the picture.

Using the Guide Number

The guide number is often of the greatest importance when we work with manual and auto-sensor flash, which are entirely based on the GN established by the manufacturer. However, keep in mind that this is only a guide number. It's not an absolute value. It guides you and the flash toward making good exposures. But that is, more or less, a judgment call. There may be nothing wrong with the guide number per se. It may just be that you prefer your flash pictures a little brighter or a little darker than you're getting from the recommended exposure settings. Or, you are working with the strobe in manual mode and attaching various light modifiers to the flash head. The manufacturer's guide number does not cover these circumstances.

Each manufacturer has his own testing procedures. While similar, those procedures may produce GN values that, in the case of your strobe, produce results that don't meet your needs. On balance, the guide number values arrived at should provide satisfactory results. However, what works for one person in one situation may not work for someone else in a different situation. You've decided it's time to test the flash yourself, under conditions that simulate your working conditions.

The testing procedure is fairly simple. First, you need the formula that determines the guide number:

$GN = f\text{-stop} \times distance$

(Remember, the flash-to-subject distance should be the same unit of measure used to express the guide number.)

To make the arithmetic simple, use a distance of 10 feet. Position a person at that distance and have them hold a KODAK Gray Card. The gray card along with skin tones and other subject values can be used to evaluate the exposure—you'll be looking to see which exposure captured subject tones and details best. Try to include a range of values from dark to light to help assess tonal range in the results.

Mount the camera and flash on a tripod. Set both the camera and strobe to manual mode and expose the film you prefer to use at various lens apertures up and down the scale, in half stops. Work systematically, beginning at the maximum aperture and work toward the smallest. (To keep everything in order, write the f-stop on a white card in letters large enough to be read in the picture and let the person holding the gray card hold this one next to it.) Be sure to make the test under the conditions in which you plan to use that particular strobe.

Here, let's say, we're using the strobe with a diffusion panel over the flash head and want to find out how much light we're losing. You find that the lens aperture that provided the best exposure at 10 feet, under these conditions, is $f/11$. Multiply 11 by 10 (the distance) and that gives you a revised GN rating of 110. You compare that with the manufacturer's GN rating, which we'll say is 160.

If we take the above formula and work backwards, we can also determine the f-stop the manufacturer's guide number would have given us at this same distance. That will help us arrive at the difference in a manner that is more readily usable.

GN / distance = f-stop

Therefore, $160/10 = f/16$. The GN value for the flash without that layer of handkerchief represents 1 stop more in light output. In other words, we lost 1 stop in the process. You can simply apply this difference at all distances, or you can recalculate the f-stop for each distance and create a table for yourself. At 20 feet, you'd use $f/5.6$ ($110/20 = 5.5$ rounded off to $f/5.6$) instead of $f/8$ ($160/20 = 8$). Fractional values may pose a problem, but round off to the nearest lower value to be conservative and avoid underexposure. You could always bracket for insurance.

Exposure Modes

Flash manufacturers have met the various exposure demands with operating modes on the flash that are somewhat analogous to those on the camera, namely automatic and manual. As with camera exposure systems, nothing is that simple, and even these modes have evolved to add to the functionality of today's strobes. There are currently numerous forms of automatic and manual flash. In some strobes and flash operating modes, the camera plays a crucial role; in others, flash operation depends on the camera only in so far as f-stop, flash sync, and film speed settings, together with flash triggering, are centered in the camera.

Although it varies with different camera systems, changing the flash operating mode is usually done on the flash, not the camera. Many flash units may offer only one or two modes of operation, while numerous others offer several more. Because of the increasing popularity of TTL automatic flash, and the significant advances it brings to flash photography, this will be the first operating mode we'll explore. Designed for simplicity, TTL flash carries with it an undercurrent of complexity that we need to understand.

TTL auto flash control

TTL automatic flash simplifies flash photography under many conditions and with potentially difficult subjects. This flash mode relies on both the camera's and the flash unit's own microcircuitry. The only proviso is that the flash be dedicated to the camera system for all this to work properly and to the fullest potential.

TTL auto flash is often achieved with the help of the camera's advanced multi-pattern metering system, which reads light levels on both the subject and the surrounding environment prior to the flash exposure. The system determines how much light the subject needs, and once the shutter is released and triggers the flash, an exposure is made that either concentrates on the subject alone or that clearly shows both the background (by ambient light) and the subject (by flash).

The specific advantage of TTL auto flash over conventional auto-sensor flash is that like conventional ambient-light TTL readings, only the light that reaches the film is metered. That means that any filters, teleconverters, extension tubes, and the like that will ordinarily affect an ambient-light exposure will be seen by the flash sensor as requiring a similar exposure adjustment to prevent exposure error. The camera takes these factors into account to deliver a proper exposure.

Another advantage of TTL auto flash is that it operates under a wider range of f-stops than would be possible with conventional automatic flash control. Select any lens aperture, and as long as there are no error displays in the viewfinder, you're free to use that f-stop. That means that you're free to exercise extensive control over depth of field, say, making a flash exposure at $f/2.8$ or $f/22$.

As this bird popped its head into the picture, the built-in flash proved useful, popping up to freeze this comical expression. Designed for convenience, the built-in flash was, in this case, TTL auto exposure, offering the photographer few (if any) options for controlling the output.

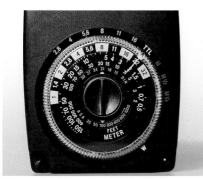

Multi-mode strobes must be set to the correct operating mode. In this case, this strobe has been set to the TTL mode. Positions to the left apply when the flash is used in auto-sensor mode, and those to the right are for manual (full-power), half-power, quarter-power, and winder mode (where output is reduced even further to provide faster recycling times).

Exposure Compensation With TTL Flash

It's difficult to pin down the exact effect bright and dark tonalities will have on a TTL auto flash system, because of variables in camera and flash design, particularly in newer equipment. However, we can assume that excessive brightness and darkness will affect TTL flash the way they affect any reflected-light exposure, until experience with any camera system proves otherwise. To be on the safe side, bracket exposures, increasing exposure for light-toned subjects, decreasing it for dark tonalities. The auto-exposure compensation function is used for this purpose. The camera's automatic exposure bracketing function may not apply to flash photography, and bracketing may need to be manipulated manually.

There is also a flash exposure compensation control on newer cameras operating with TTL dedicated flashes. This compensation function may also be a property of the TTL dedicated strobe itself. If flash compensation is activated on both the camera and strobe, the camera's programming dictates which takes precedence.

Flash exposure compensation is often confused with ambient-light exposure compensation but does not replace it. Flash exposure compensation can be used to control fill-flash,

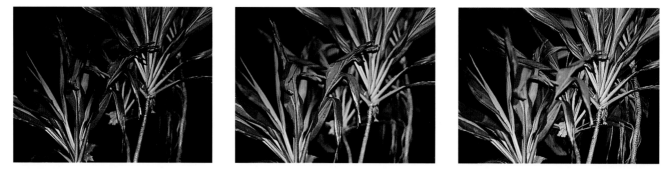

Both ambient-light and flash compensation may be used at the same time. The left photograph shows the metered exposure. The middle shot represents a +1 ambient-exposure compensation setting. The right exposure involved +1 ambient combined with +1 flash compensation. While each exposure in turn may at first appear satisfactory, the brilliant colors in these leaves are best brought out in the final exposure.

for example, by reducing flash output to create a more natural fill than the camera otherwise provides. It can also be used to correct flash output where the flash exposure may be keyed to the wrong subject tone. For instance, the flash might output too much light after reading a dark-toned subject area, or it may output too little light after being unduly influenced by a bright subject tone.

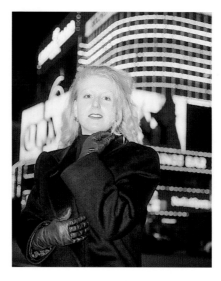

The TTL flash sensor may read the wrong signals when the focusing sensor locks onto a subject area of the wrong tonality. In this case, the camera made a flash exposure for the black coat, which occupied a dominant role in this vertical exposure. This resulted in washed-out facial tones in this fair-complexioned model (photo left). Switch to a horizontal format and the flash sensor obviously read the dark and light subject tones equally, the result being that much-improved tonalities were recorded (photo below).

Exposure correction with TTL flash: A case study

Let's say we're photographing someone with the colorful lights of Broadway as a backdrop. This person's face is fair-complexioned, but the clothing, a coat, is very dark.

Assuming the camera locks onto the subject and assesses the necessary exposure, is the exposure being made for the face or the coat? Because the focusing sensor has targeted the person, and not the bright marquis in the background, we know the exposure with multi-pattern metering is not overly influenced by those bright lights.

However, the first picture is a vertical, and the light sensor read more coat than face. The result is washed-out facial tones, although the clothing looks great. The overall exposure was fine, but it was not correct for the subject's face. In this case, flash exposure compensation would have helped with

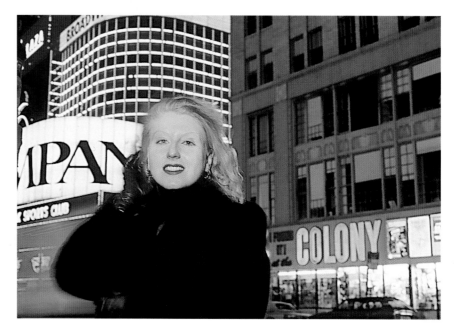

a minus value (-1 or even less flash) to tone down the flash and the skin tones. If the coat goes dark, that's not critical—the coat is not important here, the skin tones are.

Interestingly, switching to horizontal mode shows as much of the face as the coat in the picture. The light sensor reads both values, and produces a photograph with much-improved skin color. Had we locked in this exposure and then recomposed for the vertical picture, the result would have been identical.

Automatic Flash Control

Traditional automatic flash may no longer be as popular as TTL auto flash, but it still comes in handy on numerous occasions. Instead of reading flash illumination levels by way of a sensor in the camera, and consequently through the lens, these flash units incorporate their own auto-sensor. For this reason, we may also refer to them as auto-sensor strobes, especially to avoid confusion with other automatic flash units or modes of operation.

Automatic flash provides that the flash illumination will cover a subject over a wide range of distances at any given *f*-stop, if that subject is within the flash-to-subject distance range applicable to that *f*-stop. This may sound like TTL dedicated flash, which sets its operating range from the selected *f*-stop. The difference is that here you have to mechanically set the flash to the *f*-stop you've set on the lens, or conversely, set the lens to the *f*-stop dictated by the flash calculator for the subject distance. The flash does not automatically get exposure information from the camera as it does with TTL flash, nor is flash output controlled by the camera.

As technology progressed, certain auto-sensor flashes were designed to provide a modicum of dedicated operation with their matching cameras.

While these auto-sensor strobes may be dedicated, they are not designed for TTL operation. All flash illumination continues to be measured strictly by the auto-sensor. Interestingly enough, an auto-sensor may be found on the latest TTL dedicated flashes and comes into play when these flashes are used with non-TTL cameras.

When we use an auto-sensor flash unit, the sensor must always be aimed directly at the subject. The flash emits light and the sensor reads the light reflected off the subject. That determines the correct flash exposure. If the sensor detects that the light output was sufficient for the subject, then the flash-confirmation indicator lights.

On tilt-and-swivel strobes, the flash head usually can be moved independently of the sensor. If the auto-sensor is tilted with the flash head when light is bounced off the ceiling, then the sensor is not reading the light off the subject, but instead reads the light bouncing off the ceiling. That leads to a seriously underexposed picture.

Taking the flash off the camera can cause the auto-sensor to be aimed away from the subject by accident. Flash units with a removable auto-sensor solve this problem. The sensor is removed from the applicable strobe and mounted onto an adapter that is then seated in the camera's hot shoe in place of the flash. This adapter comes with its own sync cord that connects the off-camera flash to the auto-sensor on the camera.

If the auto-sensor flash is not dedicated to the camera, then the necessary flash sync speed must first be set on the camera's shutter-speed dial before proceeding. When using a TTL dedicated flash, it must be set to non-TTL automatic (auto-sensor) mode to bypass the TTL flash sensor. Certain other settings must be made on the flash unit before taking that flash picture. These are set on either the flash exposure calculator (on conventional

With auto-sensor strobes, flash distance is clearly provided—more clearly on some strobes than others. As this flash calculator indicates, at ISO 100 when the auto-sensor mode is set to the green zone (photo top), the flash will accommodate subjects to about 10 feet when the lens is set to f/11, as indicated by the (faint) red light and green bar. Position the subject beyond 10 feet, and the picture will be underexposed. On the other hand, when the flash is set to the yellow mode (photo bottom), that distance extends to about 18 feet when the aperture on the camera is set to f/5.6. Use the second setting when the subject is anywhere within a range of 18 feet from the flash. (Note that these color-coded modes and settings may not apply to your auto-sensor flash. Consult the instruction manual for applicable flash ranges.)

units) or the digital display (high-tech units). With a zooming flash or accessory panel in place, be sure the calculator (or display) reflects that zoom setting or panel.

1. After attaching flash to camera, turn both units on.
2. Set the speed of the film being used on the flash unit.
3. The camera can be set to manual or automatic mode. If the camera does not set flash sync automatically, set it manually.
4. Set the flash to automatic (auto-sensor) mode.
5. Check that the flash auto-sensor is facing the subject.
6. Set the lens aperture.
7. Focus the lens on your subject. Note the distance on the lens barrel. (Use of the focusing distance assumes the flash is on or very near the camera so that this measured distance corresponds to the flash-to-subject distance.)
8. Check the flash calculator (or digital display) to verify that the selected f-stop is appropriate for that distance or the range of distances that may be involved. There are distance indicators (which may be color-coded), and one should coincide with the lens aperture at the applicable distance.
9. If the flash will not cover the necessary distance at that f-stop, find the f-stop that will correspond with that subject distance. For example, we decide to use f/8 to cover subjects as far as 30 feet away and down to the closest recommended distance at that aperture, say 3 feet. The calculator shows that this aperture would only cover a distance up to 20 feet, whereas f/5.6 would cover 30 feet. The required aperture setting then becomes f/5.6.
10. If it's necessary to change the aperture, set the f-stop derived from the calculator dial (or

display) on the camera to avoid any exposure error.
11. Take the photograph.
12. Check the flash-confirmation indicator to verify that flash output was adequate for the subject distance.

Auto-sensor flash: A case study

Let's assume we've got an 85mm lens on the camera. The strobe does not feature a zoom head, but the flash unit's wide-angle diffuser is over the flash tube. The first thing is to remove that panel so it doesn't unnecessarily decrease the strobe's reach.

We've decided to use f/5.6 to photograph a subject at 18 feet. Setting the flash calculator to ISO 100 for the film in use, we determine that this aperture setting provides a greater distance range than necessary (6 to 30 feet). A smaller aperture would still produce a good exposure for the subject distance. However, the subject will be moving and using f/5.6 makes it unnecessary to constantly monitor the subject distance, unless it moves a considerable distance away. And if the subject moves closer to the camera by a few feet, f/5.6 should still produce a correct exposure. It will also allow for the increased distance required by bounce flash. Setting a larger aperture would have allowed for an increased subject distance, but it would have restricted depth of field. The smaller aperture gives us a little margin for focusing error, especially if the subject moves at the moment of exposure.

Manual Flash Control

The factors that result in a loss of light in automatic flash have equal importance in manual flash. In this flash mode, you have to check the selected f-stop against specific distances on the flash calculator, not a range of distances. Each time you or your subject moves closer or farther away from each other, consult the

flash calculator to find the matching f-stop for the new flash-to-subject distance.

1. After attaching flash to camera, turn both units on.
2. Set the film speed on the flash unit to correspond to the film speed set on the camera.
3. Set the camera to manual mode or to a special flash sync mode, as applicable. If the camera does not set flash sync automatically, set it manually.
4. Set the flash to manual mode.
5. Set the f-stop on the lens.
6. Focus the lens on your subject. Note the distance on the lens barrel. (Using the focusing distance assumes the flash is on or very near the camera so that this measured distance corresponds to the flash-to-subject distance.)
7. Check the flash calculator (or digital display) to verify that the selected f-stop lines up with the subject distance. Here we can't use the range of distances or color-coded indicators, as with auto-sensor flash.
8. If the flash will not cover the distance at that f-stop, find the f-stop that will correspond with that subject distance.
9. If it's necessary to change the aperture, set the f-stop derived from the calculator dial (or display) on the camera to avoid any exposure error.
10. Every change in flash-to-subject distance requires a corresponding change in lens aperture. The process of manual flash control is obviously more laborious than with other operating modes, but manual flash does have its strengths. It provides the most direct control over the lighting. Most important, it may be the only choice you have when it comes to studio flash, which may involve one or more lights

off-camera. Studio strobes do not normally have automatic sensors on them. And they certainly don't afford you the luxury of TTL auto flash operation—at least not yet.

Exposure Compensation With Automatic and Manual Flash

In contrast to TTL flash, auto-sensor and manual flash do not automatically compensate for light loss when accessories are attached to the lens. The use of any lens extension device (such as a teleconverter or extension tube) or any filter (other than UV or skylight) on the camera will result in a loss of light, in terms of the camera exposure. That adjustment has to be made manually on the camera, factoring in the amount of light lost. With extension devices, light loss is measured by the lens extension factor. With filters, it's the filter factor.

The use of a wide or tele panel on the strobe itself is normally compensated with a setting on the flash calculator directly. The flash may have its own mechanism for making this adjustment automatically. On the other hand, it may need to be done by you, manually—on the strobe.

Flash photography outdoors at night creates a situation which did not enter the guide number's calculations. Where there are no reflective surfaces nearby to bounce back some of the

For portraits on location, several portable, accessory flash units can usually provide sufficient illumination. For this shot, only a single strobe equipped with an umbrella was used. In spite of the diffused light, when the subject looked in the direction of the strobe, the umbrella was reflected in his glasses. A slight tilt of the head did the trick, largely removing those troublesome reflections.

light expended by the flash, that light is lost. While TTL and auto-sensor flash may read the light accurately, manual flash will still need some compensation to allow for the light loss. While bracketing exposures is recommended, begin by adding 1 stop to the exposure.

Taking the picture with manual flash in a very confined space, with

highly reflective walls? The reverse may be true, with too much light bouncing back onto the subject. In this case, reduce the exposure by 1 stop, bracketing afterwards.

If the flash calculator can't provide the necessary values for auto-sensor flash, but you'd like the flash to reach way out there, open up a stop or two while leaving the flash calculator set to the maximum aperture setting. You could also try this if the flash-confirmation indicator fails to light with bounce flash. The confirmation signal is really only a distance indicator— not a true exposure meter. It can give false readings on occasion, or not provide the complete picture when corrective steps are taken. It's especially prone to failure when glaring light hits the auto-sensor, which throws it off entirely.

Because flash sync is normally a given, exposure compensation applies to the lens aperture, not the shutter speed. High-speed sync, which reduces flash output, is an exception to this rule.

Note: Exposure corrections throughout this book are normally given for color slides. Color prints may tolerate under- and overexposure to a greater degree, therefore making it less necessary to compensate the exposure or bracket exposures on occasion. However, for the best results with any film, follow the corrective steps outlined.

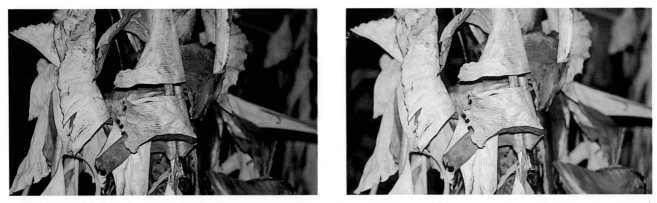

The bark peelings of this banana tree are clearly underexposed in the photo at left. Setting flash compensation to +1 produced more light and a considerably better exposure.

Film and Filters

We like to think of electronic flash as a white light. However, that is not necessarily the way strobe lighting records on film. It may actually throw an unexpected color on the subject. Differences in flash tubes— even some accessories—may distort the color cast that appears in our pictures. Now it's time to examine what can be expected of electronic flash when used with different films and what filters might be necessary.

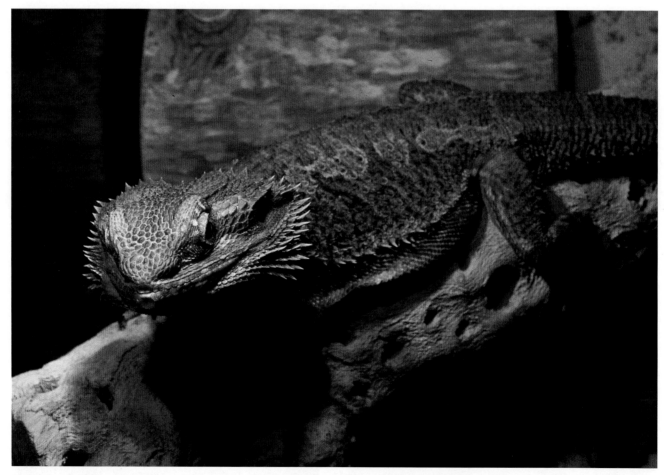

Multicolored effects such as this one can be easily created with electronic flash. Simply affix different color acetate filters over different parts of the flash tube. Another approach would be to use separate flash units, each with its own filter. In this case red, green, and blue filters were used. The subject and background should be light, neutral colors to best reflect the colorful light.

Film and Flash

Every film is designed to be exposed by light of a specific color temperature. The most popular is daylight-balanced film, which matches the noonday sun against a blue sky, with a smattering of clouds. Officially, this color light is given a designation of 5500 degrees Kelvin (5500° K).

Electronic flash normally emits light around 5500° K, which makes it a daylight-type light source. Consequently, films designated daylight-balanced are supposed to be used with either standard daylight or with electronic flash.

The other major category of film is tungsten film, or more accurately, tungsten-balanced film. Tungsten film has a color designation of 3200° K. Essentially, this film will produce near-normal colors when exposed under household incandescent illumination, such as a standard table lamp or overhead fixture. When this film is exposed by electronic flash or daylight, it takes on a bluish cast. This creates an interesting effect, one you should keep in mind when you've mastered strobe lighting. For example, if you photograph a fountain illuminated with floodlights, the fountain will appear a normal color (or nearly so) on tungsten film. Add a burst of flash to a section of the fountain in shadow (as fill-flash) and you'll add a contrasting touch of blue. We've just added a modicum of color distortion to this picture.

But what if you want everything normal, without any color distortion? Then you'll have to use filters. Filters can be used on the camera lens or on the flash head depending on the situation and the film being used.

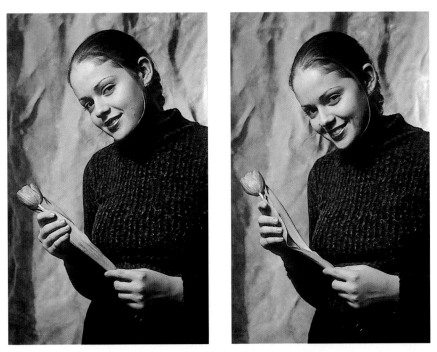

Electronic flash often benefits from the use of either a skylight filter or an 81-series warming filter. Ordinarily, the light may be too blue (photo left). The skylight filter neutralizes the color cast to some degree. Better yet, an 81-series warming filter, an 81A in this case, produces a pleasing, warm-toned image (photo right). Since umbrella lighting was used, the blue cast may have already been reduced to some degree when the light was bounced off the umbrella's white reflective surface.

Filters For Color Correction

Before we correct major color distortions that result when we mismatch lights and film, we should first examine some of the color distortions that may occur when using flash with its film of choice: daylight film.

In theory, flash emits light matching the 5500° K requirement. In truth, it often produces a slightly blue light as a result of the UV and short-wavelength blue light that is also emitted. The color is somewhat akin to light from an overcast sky. Aside from that, many flash units are stated to emit light of 5600° K and even as high as 6000° K. The higher the color temperature, the bluer the color cast that registers on color film. (This color cast may be less pronounced in color prints than in color slides, because the color

shift can be corrected in the printing process to some degree.) Certain flash tubes are specifically gold-toned or UV-corrected to render a warm-to-neutral white light.

So, what do we do about this blue color cast on daylight film? We bring out a 1A or 1B skylight filter and mount it on the lens. If this doesn't alleviate the problem to your satisfaction, an 81-series warming filter should be mounted on the lens in place of the 1A or 1B. These filters add warmth to the picture to eliminate some of the blue. Among these, the 81A and 81B are the most popular, with the B-designated filter providing a more pronounced effect.

You should test the flash with these different filters for each type of film you shoot. Each family of films

53

is slightly different: some warmer, others cooler or neutral. For example, KODAK EKTACHROME LUMIERE 100X Professional Film produces warmer tones than does its more neutral counterpart, KODAK EKTACHROME LUMIERE 100 Professional Film. The use of the X-designated film may obviate the need for corrective filtration but should be tested with your flash.

When it comes to correcting the blue color cast that results when using electronic flash with tungsten film, the recommended camera filter is an 85B (amber).

Note: One expedient measure you might try in correcting excess bluishness is to bounce the flash off the ceiling or a wall, if painted a warm-to-neutral white. Actual test exposures made in a variety of situations showed that bounce flash produced warmer results. A color-temperature test made with a special meter designed to read all three primary colors—red, green, and blue—showed that a flash that would have needed an 81-series (warming) filter no longer needed this corrective measure when the light was reflected off a white ceiling (or wall). Without testing, however, there is the possibility that fluorescing chemicals in the paint could produce a more pronounced, blue color cast. This may happen with white fabrics washed in brighteners, which contain such chemicals.

Without using filters, another way to warm up flash lighting is to bounce the light off a white ceiling or wall. As this exposure made inside a quality-control lab shows, even industrial sites produce warmer tones with bounce flash.

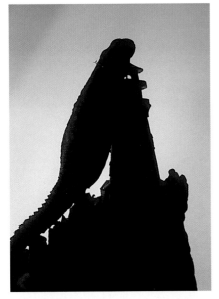

Instead of throwing multiple colors at your main subject, try painting the background with a wash of colors. Here a spiny-tailed lizard remains largely in silhouette against a colorful backdrop. The backdrop is actually a white sheet of matboard onto which filtered strobe light creates an intriguing pattern of colors.

Flash filters

There are several reasons why we prefer to use a filter on the flash head instead of on the camera lens. When the filter is used on the lens, it may affect the sharpness and definition of the image, especially if the filter is of poor quality, dirty or scratched, or mounted improperly on the lens. The problem is exacerbated as you stack one filter onto another, as when you mount a polarizing filter with a color-effect filter. Filters on the lens also affect light transmission and may cause flare. Another reason may be that you simply don't have a filter to fit a particular lens diameter, say 72mm for that fast telephoto lens.

Filtering the light source does not affect the sharpness of the image— only the color. You can add one on top of another and the only observable effect, outside of a color change, will be a loss in light because the filters

do, after all, hold back some of the light. This light loss is taken into account by TTL metering, an auto-sensor, or a handheld meter. But if flash exposure is being set manually, filter factors must be included in the calculation.

Flash manufacturers sell accessory filter sets for various flash units— most often for the better and more popular products. These filters are plastic, and look and attach to the flash the same as the wide and tele panels: either directly onto the flash head or by way of an accessory adapter. The filter range is not complete and often focuses on a neutral-density or clear panel (to decrease the light intensity or possibly hold acetate filters, respectively), along with red, green, blue, and yellow filters. If you can't find the flash filter you need in that kit, you'll find it sold in acetate sheets that you cut to size and affix to the flash head.

Flash filters provide a way to correct or alter the color of electronic flash illumination without mounting a filter on the lens and possibly adversely affecting image quality in the process. They are also useful when mixing strobe with tungsten lighting, to bring the color of flash light in line with the color of a dominant tungsten light source. The accessory filter kit shown comes with a variety of plastic filter panels that slip into a slot in the adapter provided with the kit. Different kits offer different filters and panels. Expect to find red, green, blue, and yellow or amber, with the possible addition of a clear panel to hold acetate filters that are cut to size. The kit may also come with one or more wide panels and a tele panel.

Acetate filters can be cut to fit and taped on the flash head to change the color of the light output by the flash. Photo courtesy of Eastman Kodak Company.

It is most appropriate to filter the light and not the lens when you're working with mixed light sources. Let's consider that scene at the fountain discussed in the first chapter. The fountain's floodlights are one form of illumination and the flash has a totally different color temperature. You're mixing a warm and a cool light source (relatively speaking) and exposing a film designed for the warm light source. So, if you'd prefer all the lights to record more or less as neutral white on tungsten film, mount an 85B (amber) filter over the flash, not the lens. If you used the 85B on the lens, the color of the water would be too warm while rendering the foreground, flash-illuminated structure a neutral white.

Note: Camera filters are of a much higher optical quality than flash filters. Do not use flash filters over the camera lens, unless it's for a special effect where image quality is less important than the effect you wish to achieve. Lighting filters differ from camera filters in one other key respect: They remain usable even if they get scratched, bent, or slightly smudged.

55

Creative Control

While flash photography can be as simple as activating an on-camera flash, it can also be a complex multiple-flash setup. The versatility and creative control offered by flash lighting are two of its greatest benefits.

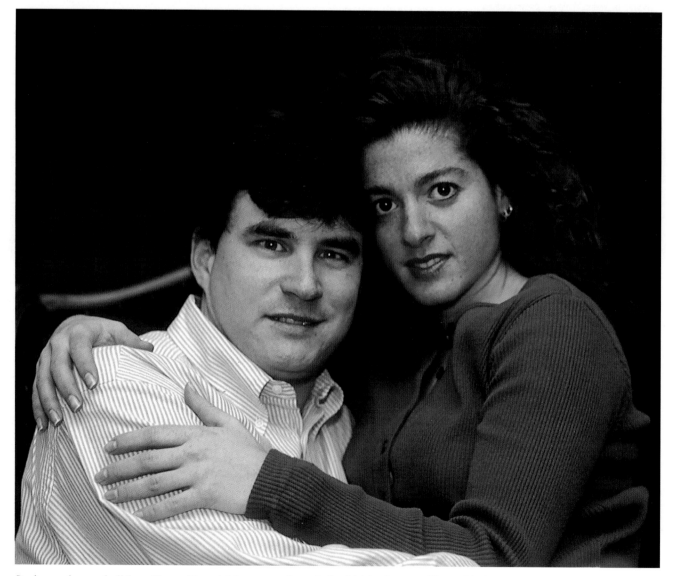

Strobe was bounced off the ceiling, with a mini-bounce card attached to kick back some additional light onto this young couple.

Advances in technology have made it easier to produce correctly exposed flash photographs. Fill-flash is one technique that today's computerized equipment has simplified and automated for us. While fill-flash exposure can be set manually, there is something to be said for the convenience and speed of having it automatically calculated by the camera. But remember, ultimate control still lies with the photographer—selecting the correct technique for the desired effect.

Modifying Flash Output

There are situations when it becomes necessary to either reduce or increase the throw of light. The flash is pumping out too much light (or not enough) to properly expose the subject. Switching to a slower (or faster) film or shifting to a smaller (or larger) aperture isn't practical. You need other choices.

The old handkerchief trick

Creative flash control can simply begin with a clean, white handkerchief draped over the flash head to reduce output. One handkerchief layer reduces light output by roughly 1 stop depending on the thickness of the material. When using an auto-sensor flash or an autofocusing-compatible TTL flash that emits an infrared beam, be especially careful not to cover these. Doing so will prevent the flash from operating properly in the applicable automatic mode. Since manual flash usage bypasses these flash aids, covering the sensor won't affect the flash, but the light loss still has to be taken into account.

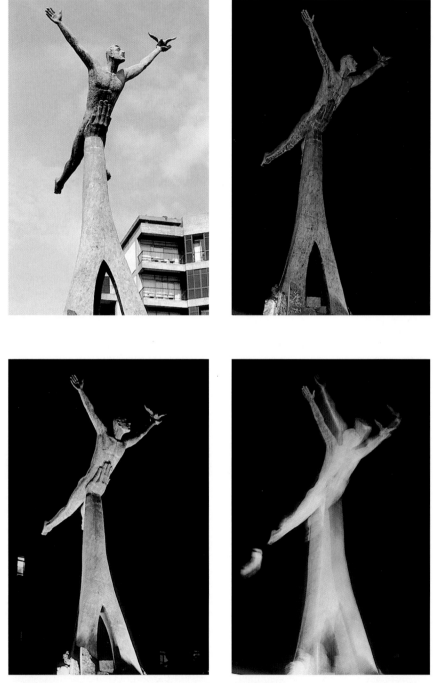

Try different techniques to get the desired effect. This statue was photographed first in daylight (upper left); the photographer then returned at night and illuminated the subject with flash (upper right). The floodlit exposure (lower left) is a warm contrast to the cold light of the flash. But then it was time to get creative by taking a flash picture using a longer shutter speed. This produced an exposure from the floodlights in addition to the flash illumination. The camera was moved gently during the 1/15 second exposure to produce this ghostly effect, making it appear as if the spirit of the statue were suddenly released and flying free (lower right).

Accessory panels and zooming

The rated guide number dictates how the flash will work under standardized conditions. Among other things, these conditions assume that the flash coverage—the spread of light—is more or less equivalent to the angle of view of a 50mm lens on a 35mm camera. That coverage may be—and often is—wider, as wide as a 28mm lens straight out of the box. (Please keep in mind that all focal lengths are given for the 35mm camera format.)

Sometimes, however, we need to match the light spread to lens coverage other than that to which the flash was set at the factory. What happens if we used a 24mm lens with this flash? The edges and corners of the picture would go dark, since the light can't reach these areas. That's called vignetting. To correct the situation, many accessory strobes accept a wide-angle panel attachment that fits over the front of the flash head directly or with the aid of an optional adapter. The panel may even be integrated into the flash head, slipping out of a hidden compartment. Either way, this textured panel disperses the light over a wider area than would normally occur. (Consult the flash instruction manual for applicable coverage with the wide-angle panel.)

Another situation may arise: Using a 105mm lens with the flash with a more distant subject gives us the opportunity to apply the tele panel, to concentrate the strobe's beam of light to reach that subject. Again, this panel attaches to the flash head directly or with an adapter.

More and more dedicated, computer-controlled flash units come with an auto-zoom head. This means that the flash tube moves its position in relation to the Fresnel lens in a manner very similar to a zoom lens. This provides the optimal light coverage matching the lens' field of view as closely as possible. Many dedicated flash units will electronically detect the lens focal length and adjust its zoom head position automatically. Unlike a continuously variable zoom lens, however, the flash unit's zoom head has fixed positions at specific focal-length settings.

Variable power output

A more sophisticated, but not always available, alternative involves using the flash-power (or variable-output) control built into the strobe itself. More often than not, powering the flash down requires the unit to be set to manual mode although some flash units may also provide this feature in automatic mode.

The flash ratio control decreases output in well-defined increments. Output may be decreased by one-half, one-quarter, even one-sixty-fourth power or lower, depending on the flash unit. When the flash ratio is set to a new value, a corresponding adjustment in the distance covered by any given f-stop is displayed by the flash calculator.

Decreasing output reduces the throw of the light. If at ISO 100, you had set $f/5.6$ on the lens to cover a subject distance of about 15 feet, setting the power ratio to one-half output now means the flash will only reach about 10 feet. Each halving of power corresponds to a one stop loss in light output. Failure to make note of the applicable change will result in exposure error.

Decreasing power does more than decrease light output. When the flash needs a smaller amount of energy to deliver an exposure, it also requires less of the stored charge in the capacitor. For example, in the above situation, if a 10-foot working distance would be practical, then we could decrease output by one-half at $f/5.6$. That leaves energy to spare. The benefit is that recycling times are shorter. The faster recycling also conserves battery power and may even make it possible to shoot several exposures in relatively rapid succession, with greater spontaneity.

Here's a little trick: If you find that your batteries are too weak at full power and assuming that your subject is close enough to make decreased power output a viable option, set the power ratio down as far as practical and you'll be able to squeeze out a few more exposures from those batteries.

Bounce Flash

Bounce lighting is a simple technique. Instead of aiming the strobe directly at the subject, you aim it at a reflective surface and use that surface to bounce the light back onto the subject. It is one of the more popular flash techniques especially for portraits. The harsh contrast resulting from direct flash is unflattering to say the least. Bounce flash is preferable for its softer lighting and subtle shading, adding dimension to the subject.

While the most readily available surfaces for us to use are ceilings and walls, virtually anything can be employed to reflect this very accommodating light form back onto the subject, provided we are aware of the following:

- Bounced light travels a longer distance to reach the subject, since it is taking an indirect route from its source.
- The light scatters to some degree when it hits a reflecting surface, scattering more and more, the rougher the surface texture.
- Some of the light is absorbed by the surface used to reflect it.
- A direct result of that increased travel, scattering, and absorption is that light is lost and we have less light to work with.
- The light strikes the subject and background at an angle, the result being that the subject takes on a more three-dimensional look and any background shadows become less intrusive.

Because this window was curved inward, no reflections were apparent with direct flash (photo top). However, bounce flash gave the displayed figurines a more three-dimensional appearance (photo bottom). On the other hand, the bounce light was weaker and required a larger aperture so that the interior fluorescent lighting produced ambient-light exposure.

- The light comes off the reflecting surface at the same angle it struck that surface in the first place: The angle of reflectance equals the angle of incidence. The farther the subject is from the strobe, the smaller the bounce angle required. The closer the subject is to the flash, the greater the angle needs to be.
- Bounce flash requires either a movable flash head or off-camera operation. A flash seated on the hot shoe must be capable of tilting upwards and rotating about its axis. When the camera is held horizontally, an upward tilt is required to bounce light off the ceiling; the swivel is necessary for bounce lighting off a wall (with an upward/forward tilt for a better lighting angle).

These Madeiran club performers were photographed with and without bounce flash. Bounce flash presents them in a warmer and more inviting light (photo top). Direct flash produced a harsher light (photo bottom). Notice that the bounced light fails to reach the musicians in back, due in part to the structure of the ceiling.

- Because of the loss of light encountered with bounce flash, it's important that the TTL sensor—specifically the camera (in TTL flash) or the strobe's auto-sensor (in auto-sensor automatic flash)—be aimed at the subject to correctly read the light level.

How much light are you losing with bounce flash? Typically allow 2 full stops. If you found that an *f*/5.6 exposure was adequate to cover a subject 10 feet away, you'll find that bounce flash might require *f*/2.8 to make up for the lost light. Other factors may increase the light loss.

Walls and ceilings

Owing to their variability, certain walls and ceilings may produce unexpected and unwanted results. Ordinarily, we rely on white ceilings and white walls for bounce lighting. Walls that are wallpapered or painted any color other than white will reflect a tinted light that may cast an ugly pall on the subject, worse with some colors than with others. Dark walls will absorb considerably more light and generally prove entirely unsuitable for this application. Heavily textured wallpaper will absorb and scatter a disproportionate amount of light, making it unsuitable as well.

Other considerations, in addition to texture and color, that apply to ceilings: The ceiling may be too high, such as a domed ceiling or even a high ceiling in older buildings and ballrooms. Ceiling beams and door frames or hanging fixtures may block the light from reaching the subject. Ceiling bounce works best with level white ceilings of average height.

Bounce cards

You've no doubt heard about bounce cards and have maybe even seen them used. The bounce card is mounted onto the flash head and held in place

Not wanting to use direct flash for this budgie in its cage, the author used bounce flash. The problem was that the only nearby surfaces were the white walls to the right and behind the cage, and the side of a wooden cabinet. The ceiling was ruled out at the start as inappropriate. Since it was behind the bird, the adjacent wall wouldn't work, nor would the cabinet, which would produce an overly warm color cast. With the flash handheld near the reflecting surface, the back wall was used by default in part to avoid disturbing the bird.

The lobby of this building would have presented an interesting design study, had it not been for the overhanging arch which blocked the light from the flash bounced off the ceiling. Whether it's an arch in the lobby, a simple door frame, or ceiling beams, these are obstacles one must be aware of when using bounce flash.

by some means—even a rubber band might be suitable in a pinch. The flash head is often pointed up to bounce light off the ceiling. The bounce card itself is commonly angled to catch the light and redirect it at the subject.

What does the bounce card do? When light is bounced off the ceiling, it adds a catchlight to the eyes, plus a little fill. In a sense, the card serves the same purpose that the sub-flash in a twin-flash-tube strobe serves. You have to be fairly close to the subject and in a low-ceilinged room for the bounce card to work well.

The more common bounce device is angled over the face of the flash tube, and may wrap around three sides of the flash head, to prevent stray light from spilling out past its edges. This directs as much light as possible onto the subject.

You can buy a bounce device at your photo retailer. These devices come in all sizes. Smaller ones are

A new trend is emerging, where a mini-bounce/ kicker card is incorporated into the strobe head. It's recessed and pulls out when needed. The add-on mini-bounce card attaches to an adapter that slides onto the flash head. This adapter alternately accepts a larger fill card that is about the same width as the flash head. The kicker card is used to kick light back into the face when a steep bounce angle is used, and it may also add catchlights in the eyes. When it is used, a full-size bounce device often serves as the main light source, not simply as a kicker light.

easier to carry around. Fancier and larger bounce cards may include a diffusion panel that fits over the flash head to diffuse the light further.

Bounce lighting with a bounce card still means you lose some light. Even if there were no light spill, some of the light is still scattered. You may lose up to several stops, depending on the device. To compensate, try setting the zoom position on the flash to telephoto (if applicable to your flash) or use the tele panel on the flash head. Some experimentation is in order to make sure this will not produce vignetting with a wide-angle lens.

Eliminating Red-Eye

Light emitted along the optical axis— in a straight line, more or less, with the lens—seems to seek out wide-open eyes, more specifically the pupils, and causes them to turn red. More to the point, light entering the pupils hits the blood vessels at the back of the eye. This light then picks up a red tint and is reflected back out toward the camera lens. Voilà! Red-eye.

This is more common with built-in flash because of its close proximity to the lens, but also happens with accessory flash units. If the camera or flash has a red-eye reduction mode, it can help alleviate the effect. The strobe emits a fairly strong beam of light or a series of weak pre-flash bursts. This light strikes the eyes and causes the pupils to contract, thereby either eliminating or at least lessening the effect. The chief drawback to this form of red-eye reduction is that the flash calls attention to itself. What's more, even the brief time required for a pre-flash may result in losing that spontaneous expression.

Direct flash produces red-eye in the cockatiel but not in its owner (photo top). Still, there's a way to get the red out of the bird's eye and produce an even more pleasing portrait, with bounce flash (photo bottom). Also, notice how bounce flash gets rid of the glaring reflection on the woodwork in back.

What do you do when there is no red-eye reduction mode to turn to or when this approach seems impractical? The accessory strobe may provide its own solution. Because the accessory unit sits higher on the camera than the built-in flash, it is less likely that light will enter the eyes in that same direct line of sight to produce the phenomenon. Red-eye can still strike, although not necessarily with the same intensity as would occur with the built-in flash without red-eye reduction. Using the flash off-camera to distance the flash beam from the lens axis is the best way to eliminate red-eye. Bounce flash is also an effective countermeasure.

Green eyes? You might be surprised to find that red-eye in some animals is anything but red. One close-up with flash produced a green-eye effect in the author's cat. In another cat photographed from a distance, the eyes glowed yellow.

Fill-Flash

Fill-flash, or flash-fill as some like to call it, is one of the key ingredients to successful flash photography outdoors. Even indoors it's useful but often to a lesser extent.

We use fill-flash to lower harsh contrasts encountered in strongly backlit or sidelit situations, such as when photographing children playing on the beach, with the sun at their backs. While your eye can readily see the detail in their faces, photographic film has trouble resolving that detail and at the same time capturing that beautifully textured, bright background surrounding them. When the

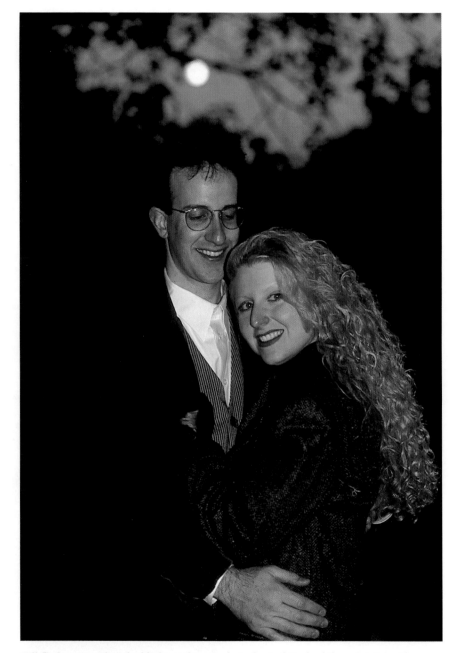

Fill flash was used to shed light on this couple in Central Park while maintaining the ambience of the moon shining through the trees.

camera's meter reads the scene it has to make a choice: Does it make the exposure for the beach and sky or the kids?

Today's multi-pattern metering systems have evolved to tackle this very problem. They attempt to bias the exposure for what's most important to the picture—often taking their cue from the focusing sensor, which, we'll assume, is focused on the kids in this case. That may let you see the ice cream dripping down a child's chin in the picture, but it may also result in washed-out detail (a loss of highlights in the lighter parts of the scene) in the landscape behind the children. Any way the meter looks at it, you lose, because some detail will be lost if you rely strictly on a conventional ambient-light exposure.

So we still have to face our original dilemma: How do you capture the kids' cute faces and the bright backdrop at the same time? The answer is to use a fill-light.

Balanced fill-flash

Providing the right amount of flash illumination to balance the subject and background light levels can take two forms. One is where the subject exposure by flash equals the background exposure by daylight, the result being that the subject appears artificially lit. In some respects, this might even look surrealistic, since we would expect less light on the face of our subject than we're getting—and that's not altogether bad. Returning to our example of the kids on the beach, the important thing is that we were able to record the background together with those kids. And that was achieved with this fill-flash approach.

The bright sky and light reflected off the lake contributed to underexposure in the available-light portrait of this young woman, as seen in this more encompassing view (photo above). TTL automatic flash added the necessary fill-light for a portrait that focused more on the woman than the setting behind her (photo right). Moreover, because the model was fair-complexioned, flash output was reduced using the flash exposure compensation control to provide a slightly darker skin tone.

A natural fill-light would be less intense than the backlighting. Fortunately, it is possible to control the flash so that there is a more natural balance of light in the picture. The degree of control you have over fill-flash varies with the flash unit and camera. We'll begin by looking at TTL dedicated flash systems and conclude with fully manual operation.

These migrating cormorants made a stopover in New York City's Central Park and were taking a moment to sun themselves on this bright day. Contrast is fairly high, as is evident in the shadows in the photo at left, taken without flash. Flash subtly filled in the shadows, maintaining a sense of the bright ambient light in the photo at right. Look closely and you'll see a glint of light in the cormorant's eye facing the camera, a hint that flash—in this case, on-camera—was used.

TTL auto fill-flash

The combination of a computerized, autofocusing SLR with a computerized, autofocusing-compatible dedicated flash is a recipe for success with fill-flash. Here is generally how it works:

1. Turn the camera and flash on, and set the camera to any applicable automatic mode (per the instruction manual). Set the flash to TTL auto mode.

2. Press down halfway on the shutter button and focus on the subject. The camera's exposure sensor reads the ambient light levels in the scene.

3. Release the shutter and the TTL dedicated flash fires. The flash sensor reads subject reflectance and determines flash duration. (Note: Prior to the actual light burst, the strobe may emit a pre-flash, which the camera then uses to determine flash output.)

4. The exposure is complete. Fill-flash is automatically achieved for a backlit (or sidelit) subject. If programmed to do so, flash output is reduced to yield naturally balanced fill-flash. Stop here or proceed to the next step for greater creative control.

5. The camera's programming may be such that the flash output matches the background exposure. In this case, use the flash exposure compensation and set it to -1, for one stop less flash light for a natural fill effect; more (-1-1/2 to -2) to reduce flash output even further. Stop here or proceed to the next step for greater creative control.

6. An excessively bright background may lead to underexposure for the ambient-light portion of the exposure (for the backdrop). Use auto-exposure (AE) compensation to increase ambient exposure accordingly. This can be done in combination with flash exposure compensation, if necessary. (Note: Owing to programming variables, each camera's metering system may respond differently to the same scene. For best results, at least at the outset, bracket the ambient-light exposure at Normal, +1/2, +1, and +1-1/2, using autoexposure compensation.)

TTL auto fill-flash, it would seem, makes it unnecessary to even think about attempting fill-flash any other way. Yet there are those who feel more comfortable exercising total control over the situation and still others without access to a TTL dedicated system who require an alternative procedure. Fortunately, another option does exist.

Note: Subject to camera and flash design, setting the camera to manual operating mode or pushing a special override function on the strobe itself may bypass TTL automatic fill-flash while still providing TTL flash duration control. Setting the flash to manual mode, however, circumvents TTL flash entirely and in combination with a manual-mode setting on the camera, provides full user control of exposure.

Manual fill-flash

By setting the flash to manual, you can exercise individual control over the degree of fill light. Using a flash in auto-sensor mode is not advisable, because the auto-aperture and distance ranges introduce variables of their own. (Note: Consult your camera and flash instruction manuals for any special settings or sync connections that may be required in order to permit full user control.)

Here is manual fill-flash, step by step:

1. Set the flash and camera to manual mode, being sure to set the film speed on both. This provides control over all settings.

2. Set the shutter-speed dial to the correct flash sync speed. Set the power ratio control to full output. Remove any accessory panels and set the panel index to the normal position (no panel attached).

3. Focus on the background and take a meter reading with the camera. As you take the reading, adjust the *f*-stop on your lens until the camera's exposure meter shows that it coincides with the necessary flash sync speed for your camera. For example, if flash sync is 1/60 second, a reading of the background might yield *f*/11 at 1/60.

4. Focus on the subject and note the distance indicated on the lens' focusing scale. Let's say that's 10 feet.

5. Transfer this distance to the flash calculator or digital display on the back of the flash. With the flash we're using, a distance of 10 feet happens to coincide with *f*/11. Taking a flash exposure at *f*/11 would yield an artificial-looking balanced fill-flash situation. (If the subject were originally at 7 feet, adjusting the power ratio control would have been necessary to match up the metered *f*-stop and the subject distance. For example, it may have been necessary to set power to 1/2 so that a distance of 7 feet lines up with *f*/11.) Stop here or proceed to the next step for greater creative control.

6. To reduce fill-flash to a more natural look, set the power ratio control down to the next lower setting. If it's at Full, set it to 1/2. (If it was 1/2, set it to 1/4.) This means you are giving the subject 1 full stop less illumination than what the meter determined for the background. You

can even take it down further: If the ratio control has a detent setting halfway between 1/2 and 1/4 (or, respectively, halfway between 1/4 and 1/8), use that setting to give the subject 1-1/2 stops less light. To tone the subject down further, take the power ratio down to 1/4 for a subject 10 feet away (1/8 for a subject at 7 feet), for a more marked effect with 2 stops less fill. Stop here or proceed to the next step for greater creative control.

7. When the background is excessively bright, the meter reading may lead to underexposure for the ambient environment. To compensate for this brightness, add 1 to 1-1/2 stops to the background exposure, depending on the level of brightness, being sure to set the new *f*-stop on the camera. That means that the original *f*/11 exposure might start at *f*/8 (at +1 stop). If that's the case, follow the above steps based around an *f*/8 background exposure instead. To simplify the procedure for an *f*/8 exposure with a subject distance of 10 feet, set the power ratio to 1/2 and proceed from there. (This would be the same as if the subject were originally photographed at *f*/11 at a 7-foot distance.)

If after following the above procedure, you find it difficult to work with manual fill-flash, try this more direct approach (after making all the preliminary settings on flash and camera):

• Take a background exposure reading at the flash sync speed. Say it's *f*/11 at a sync speed of 1/60 second.

• Match that *f*-stop with a corresponding subject distance derived from the flash calculator. We'll use 10 feet. At this point, an *f*/11

exposure with the subject at 10 feet gives you balanced fill-flash. Stop here or proceed to the next step.

• For a more natural fill, cut back on the flash output by applying the wide panel or a white hankie over the flash head, or by

employing a wider zoom-head position or a reduced power-ratio setting. Stop here or proceed to the next step.

• Compensate for excessive background brightness by opening up to a larger *f*-stop and making all settings accordingly.

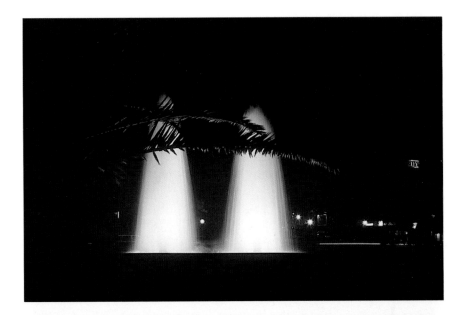

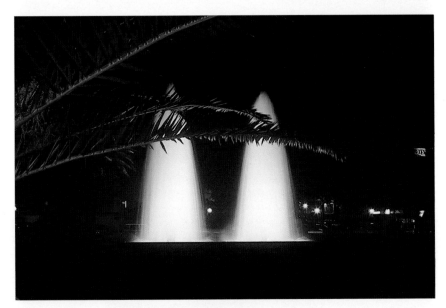

A relatively long exposure on daylight film was used to add flowing movement to this fountain. The problem was the palm fronds in the foreground: They could add depth to the picture if only they were not silhouetted (photo top). Fill-flash added just enough light to the plant (photo bottom). Shutter-priority mode was used to set the necessary shutter speed.

Fun Flash Adventures

Creative opportunities with flash exist at every turn. Several of these represent new territory for many of us, a domain involving innovative technology and advanced, high-tech strobes. Our fun flash adventures will take advantage of all the features offered by these strobes, principal among them second-curtain sync, slow-sync, and stroboscopic flash. Even less-sophisticated flash equipment can produce creative, exciting photographs, as will become apparent when we create silhouettes and colorful light paintings.

The short duration of a flash burst freezes fast-moving subjects. For this photograph, the camera was set up in a darkened room with the shutter held open. A flash, equipped with a sound trigger, fired when the pellet broke the bulb. Photo courtesy of Eastman Kodak Company.

Flashy Silhouettes

Creating a silhouette with flash is not much different from creating one by available light. The difference is we're artificially generating the bright background light. Begin by lighting a white wall behind the subject with off-camera flash. (Later on, try this with two lights—one on each side, for a more even wash of light.) Take a meter reading off the bright wall, compose the picture, and release the shutter. This now leaves the subject severely underexposed, so that he becomes a two-dimensional shape—a shadow of his former self. A silhouette.

The subject should be positioned several feet in front of the backdrop to prevent light from spilling onto him. Also, don't let ambient light illuminate the subject; turn out the room lights and close the curtains. For a somewhat different result, position the subject closer to the wall. This increases the possibility that some of the background light will spill over onto him, along one or both sides, to create a rim-lighted effect.

Friendly Ghosts

One of the basic tenets behind using flash is to freeze moving subjects that might otherwise be blurred on film. But that gets tiresome after a while. Many photographers have opted to be more imaginative by intentionally blurring the subject—while freezing it.

The key here is to use flash in an environment with subdued lighting but which is otherwise amply bright to record a blurred image on film. The result will be at its best with colorful subjects in motion, such as a calico cat with a red and blue bow pouncing on a toy, kids jumping about in colorful holiday garb, or an energetic dance recital in traditional dress.

Set the flash exposure for the aperture appropriate to the ambient lighting and flash-to-subject distance. Set the camera to manual or shutter-priori-

Electronic flash can create dramatic silhouettes. This dinosaur attack on a lighthouse was staged with the author's spiny-tailed lizard and an ornamental aquarium sculpture. The only illumination was a single flash unit placed behind the scene.

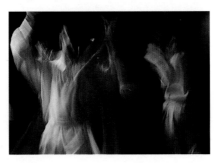

Flash is barely evident as available light records this ghostly blur of motion.

ty mode, choose a slow shutter speed, and bracket exposures by changing shutter speeds to vary the effect. Someone moving quickly out of the picture frame will require a faster time. Someone zigzagging or moving in circles around a central position may even tolerate a longer exposure. The movement records as a sharp flash image, combined with a ghostly blur of color.

Another trick, but with more subtlety, is to simply and lightly tap the lens during a long exposure, with the camera on a tripod. This superimposes a blurry outline around the subject, appearing almost as a shadow, but

ghostly and more intriguing. You can achieve a similar effect by having your subject move slightly or by shooting handheld, assuming you induce a little camera shake.

High-Key and Low-Key Lighting

High-key creates the impression of a lofty, ethereal, even a romantic setting. Light colors and pastels dominate the picture and may be contrasted by a small dark patch or two. Low-key has the opposite effect to high-key. It conveys a dark, somber mood. The predominance of dark tones, contrasted by perhaps one or two small areas of light color—even if that is just a reflection off your subject—will set the tone.

When creating a high-key mood, try using hard, sidelighting and a soft-focus filter on the camera to enhance the effect. Soft focus flares out the highlights, which elevates the spirit of the image. Soft lighting on its own may also work, with the added help of overexposure. Keep in mind that light-colored subjects require additional exposure at the outset to restore the original tonalities. Beyond that, bracket by overexposing up to +1 stop or more, so you can choose the effect you like. A natural subject choice for a subtle high-key portrait is a bride wearing a white wedding gown, with a touch of soft focus and a modicum of overexposure.

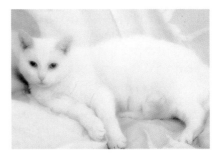

High-key: A predominance of light tones, soft lighting, and soft focus came together to produce this high-key portrait of the author's cat.

Overexposing by 2 or 3 stops will lead to interesting results with certain subjects. Focus on a person's face made up with heavy red lipstick and sufficient blusher to highlight cheek-bone structure. This approach might even work well with a colorful clown.

A bridegroom wearing a black tuxedo might not be the best low-key candidate, although the mood expressed can simply be subdued, such as when he's sitting alone pondering his future. A mourner in black is an obvious choice. Use a dark backdrop to support the mood. Underexposure can be used to enhance the low-key effect, but be careful not to overdo it. Keep to an exposure between normal to one stop underexposed, and bracket around an exposure that may also compensate for possible overexposure of dark-toned subjects. You won't know what will work best with individual subjects and scenes until you try.

Sidelighting that calls our attention to a contrasting subject highlight, perhaps combined with soft focus, can add a dramatic touch to a low-key photograph. It helps if the light can be made to fall off, so it doesn't light the entire subject or the background.

Painting With Light

To try painting with flash, an off-camera strobe with a test button is needed. Also, a sturdy tripod and locking cable release are required for a long exposure. You'll be firing the flash with the test button, so you won't need a sync cord. The subject should be in total darkness or very low light.

First, set the camera to manual mode. Determine the flash-to-subject distance and set the appropriate aperture on the camera. If possible, use auto-sensor flash which will allow a distance range for the set aperture. Use the cable release to lock the shutter in its open position on B (Bulb) for

Low-key: Keeping the lighting, the exposure, and the clothing subdued combined to create a low-key effect in this portrait. It also helps that the subject is not smiling or acting in a lighthearted manner, which might contradict the mood conveyed by low-key lighting.

Using a single flash unit, it took almost 30 minutes to record this unusual home. Numerous flashes were required and the photographer had to be careful not to overlap the light, which would have produced an uneven exposure. Between flashes an assistant covered the lens without touching the camera. Photo courtesy of Eastman Kodak Company.

a time exposure. Stand at the determined flash-to-subject distance and fire the flash repeatedly, moving the flash each time to light the entire subject. Release the cable-locking mechanism to complete the exposure.

Be careful not to overlap flash bursts too much or areas of the subject may appear washed out. Also, enlisting a friend to cover the lens

The photographer made a time exposure that showed star trails and a silhouette of the house. On cue, an assistant inside the house fired a flash unit to illuminate the windows. Photo courtesy of Eastman Kodak Company.

between flash pops will help prevent ambient light exposure. Try not to wander too far from the established flash-to-subject distance or the lighting will be profoundly uneven. Dress in dark clothes and take care not to stand between the camera and flash. Keep the flash head turned away from the camera, otherwise, the light source will appear as a series of blips across the image. As an alternative, use a wide-angle lens and position the camera close to the subject area. Now it's possible to stay back and out of range of the lens while repeatedly popping the strobe.

Flash Effects With Filters

Filters are often used on flash to add a splash of color, not merely to correct color distortions. You can paint a subject with one color against a setting washed in natural light, creating something seemingly out-of-this-world—a striking contrast of the unexpected against the norm.

Unlike filters mounted to the lens, flash filters do not have to be of optical quality. The filters included in an accessory filter kit, acetate gels for theatrical lighting, or even colorful plastic wrapping cut to size can be used. Mount the filter on the flash head, use tape or a rubber band if necessary, and take the picture.

Different filters hold back varying amounts of light; using TTL or auto-sensor mode is the best choice for flash exposure control. Where available light is also involved, TTL auto fill-flash is recommended to expose the background properly along with the flash-illuminated foreground subject. When using manual strobe, it becomes necessary to determine flash exposure with each filter. The camera, however, should still be set to manual.

Painting with filtered light follows the same basic steps outlined earlier for painting with flash. Using different filters in the photograph can create a tapestry in colored light. Find the simplest and most efficient way to change filters or use more than one flash unit. Next, take the flash and begin popping it so that the light covers your subject—say the front of a house—entirely. Change filters between pops if desired. Some of the colors will overlap, with varied results. You've now created your own enchanted world of color, vibrant and mesmerizing.

A red filter was placed over the flash, not the lens, to add color to the silver tube portion of this miniature kaleidoscope.

Slow-Sync Flash

Autofocus TTL dedicated flashes come equipped with features that readily lend themselves to fun flash adventures. Slow-sync flash is only the beginning.

It's nighttime, and you and a friend find yourselves in front of a bright, picturesque setting—say New York City's colorful Broadway theater district. If you use flash conventionally, you'll certainly capture your friend on film but that beautiful backdrop will be barely visible. What went wrong? The exposure wasn't long enough to record the ambient light. What's the solution? Slow-speed synchronization.

Slow-sync, as it's often called, combines flash with a long exposure time replacing the usual flash sync speed. This allows enough time for those spectacular background lights to record on film.

Slow-sync can be a fully automatic function of the camera. When the built-in flash or a TTL dedicated accessory flash is activated, and once you press the shutter button, the camera's microprocessor evaluates the background and the subject and delivers a colorfully balanced exposure. However, if it isn't a feature offered by your camera, you can set a slow shutter speed manually. If your camera cannot meter very long exposure times, use a handheld exposure meter.

Use a tripod for slow-sync or else camera shake will cause the background, and possibly the subject, to blur. Provided it does not move, your subject will be sharp because of the flash exposure. If there is any movement in the background, it will appear as a blur coupled with the sharp flash image.

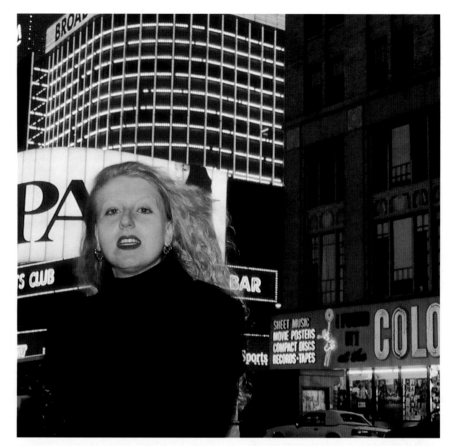

The camera's slow-sync mode was used to expose the foreground subject with flash while maintaining the background ambiance in this New York City scene. Owing to the slow shutter speed, the model's movement resulted in some blur, apparent as a ghosting effect in her hair.

Second-Curtain Sync

The second-curtain sync, also known as rear-curtain sync, flash feature records a phantom trail behind a clearly visible flash image of a moving subject. Using flash with a long exposure time would still produce motion blur and a sharp flash image. The only problem is that the blur would appear to precede the subject, instead of follow it. This looks unnatural: The subject seems to be moving backwards.

With normal synchronization, the flash fires at the beginning of the exposure as soon as the first shutter curtain has opened completely. If second-curtain sync is set, it delays flash triggering until the end of the exposure. This gives the camera enough time to record the ambient-light exposure first as a blur and make it appear to be naturally flowing out of the flash exposure.

For successful results with the second-curtain sync feature, it is generally preferable for your subject to be set off against a dark barkground. However, there must be enough ambient light on the subject to record it without flash, with a relatively long shutter speed. Timing is critical. If the exposure is too long, the subject may be out of the picture frame before the flash fires. Giving your subject a mark will help them stay in the frame.

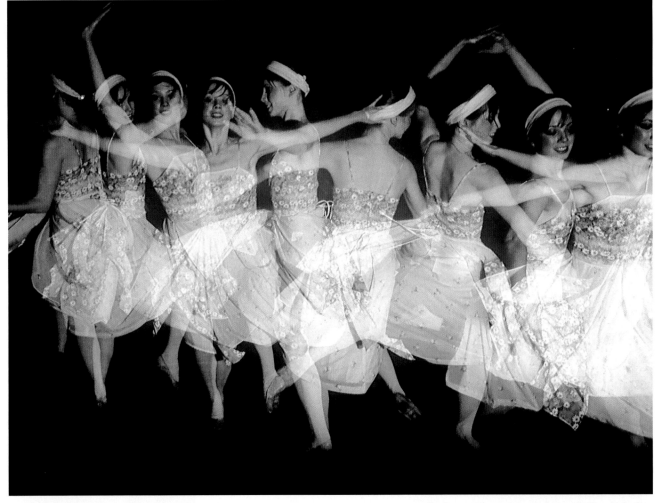

A flash unit with stroboscopic mode will fire many times in rapid succession to produce multiple images on a single frame of film. A dark background and light-colored subject usually yield the best results. Ambient light should be kept low to prevent ghosting. Photo courtesy of Eastman Kodak Company.

Stroboscopic Flash

Stroboscopic flash provides us with a way to record multiple images of a moving subject on one frame of film. While this mode does not convert the flash into a true stroboscope, it does produce multiple light bursts sufficient to simulate the effect with stop-action imagery.

Any moving subject will do: a runner, a dancer, a ball bouncing, or a windup toy going through its paces. To begin, you'll need an accessory flash that provides this function. And you'll have to work in total or near-total darkness. Otherwise, your multiple images will appear to be multiple ghosts. It also helps to have a dark background and light-colored subject.

Set the flash unit to stroboscopic mode and program the number of flash bursts and the frequency. The number of bursts dictates how many times an image of the subject appears in the photo, the frequency controls the distance between each image. On the camera, set the *f*-stop suitable for the subject distance and a shutter speed long enough to encompass the number of flashes set. For example, if the flash unit is set to fire ten bursts at a frequency of five per second, a shutter speed of at least two seconds must be used.

Expect some overlap between images. Too much overlap means you haven't timed the action correctly or are trying to capture too many images on a single frame of film.

Note: Any time you use a long shutter speed, as with slow-sync, stroboscopic flash, or second-curtain sync, use a sturdy tripod and locking release. Always leave some slack in a cable so as not to induce camera shake.

Advanced Flash Techniques

Our focus at this juncture will be on those tools and techniques that help us to take professional-looking pictures right in our own home. We're looking to add sparkle to our pictures, perhaps to make them more dramatic or more romantic, or just to present a more personal viewpoint, a unique statement. Naturally, it helps to be able to control the illumination, which is not always possible with existing light. Flash allows us to photograph views that would otherwise be difficult or even impossible to capture. Finally, we'll explore what it means to set up a small home studio, with flash lighting serving to illuminate all the creative possibilities.

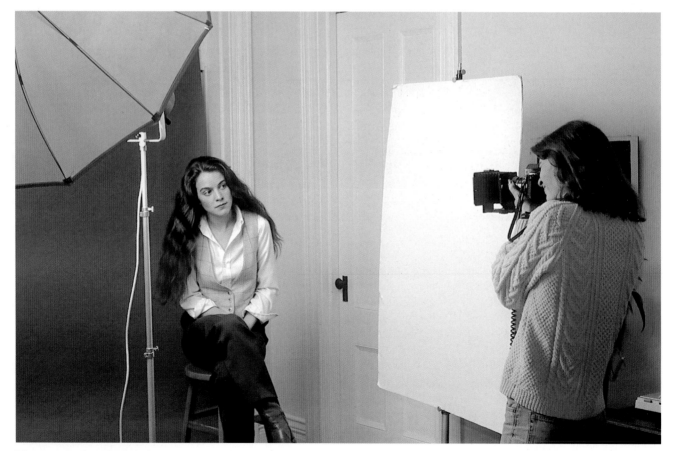

The most simple multiple-lighting setup—one flash unit and a reflector to bounce fill light onto the subject. Photo courtesy of Eastman Kodak Company.

Multiple Flash

One flash unit can do an awful lot, no doubt about it. Add a reflector to bounce light back onto the subject to fill in shadow areas, and you effectively have a multiple-lighting setup. Yet that's not always satisfactory. Reflectors can only go so far when it comes to throwing light on a subject. Beyond that, we must turn to additional strobes to take up the slack.

For the present, we're concerned only with shoe-mount and handle-mount strobes operating off the same camera. Let's see how we can get the camera to trigger two or more flashes at the same time.

First we have to consider which type of flash we're using: TTL, auto-sensor, or manual. We can immediately rule out working with multiple units that are auto-sensor controlled as impractical, unless we switch them over to manual flash mode. With any strobes, TTL dedicated or otherwise, we'll also need the proper accessories to synchronize flash firing with shutter operation.

As you begin to add one or more strobes to a set, you suddenly discover new and intriguing qualities in your subject. Each takes on a special function. One flash can serve as the main light, or key light, while a second serves as a fill-light, backlight, or hair light. The fill-light, as we already know, reduces the contrast, but what can a backlight and hair light do?

First, the key light serves to define and contour the subject. It is normally the first light we set up. It's often placed at the front and to one side, at a downward angle relative to the subject. Usually positioned near the camera, the fill-light comes after but is not always a necessary component in our pictures. The fill-light must be subdued enough so it doesn't cast a second shadow on the set.

Backlighting helps to separate the subject from the backdrop when used in combination with the key light. Routinely aimed at the backdrop, this light gives the picture added depth, enhancing the subject.

Multiple Lighting With TTL Flash

A multiple-lighting setup with TTL dedicated automatic strobes is a logical choice for the sheer convenience it provides: multiple lights, one camera, one meter reading—automatically and through the lens. Still, we have the problem of getting the camera and individual flash units to communicate with each other.

Earlier we discussed the need for a sync cord when shooting with off-camera flash. Our first option with TTL auto flash is to employ a modular approach that calls for dedicated accessories: A TTL hot-shoe adapter sits in the camera's hot shoe. This then connects to several compatible flashes—compatible meaning TTL dedicated units of similar manufacture by way of a dedicated sync cord attached to a dedicated multiple-flash connector. Each flash requires its own connecting cord and off-camera shoe adapter or the equivalent, depending on design, and each hooks up to the dedicated connector. Three such off-camera strobes is usually the limit.

Mount the individual off-camera flash units on tripods or light stands positioned around the subject for the lighting effect desired. Dedicated connecting cords often come in different lengths. You should consider buying several cords of varying lengths to give you greater flexibility in positioning the lights.

What do you use to trigger all the flashes? The one shutter button on (or electronic remote release connected

With the help of compatible accessories, it's possible to take pictures with from one to three TTL-type strobes connected to the camera. Illustrated here are the necessary components, which include an off-camera TTL hot-shoe adapter, a three-way TTL connector, individual TTL shoe adapters, and TTL connecting cords. The dual TTL strobe system pictured here is attached to an accessory macro bracket. Longer TTL sync cords can be used to position the strobes anywhere around the room.

to) the camera is all. The entire TTL auto flash exposure is judged by the flash sensor in the camera, which takes each light and its contribution to the overall picture into account.

Wireless TTL Flash Triggering

Certain TTL dedicated systems feature strobes that can be triggered remotely, with a photo slave instead of a sync cord attachment. These incorporate a sensor on the face of the unit. When the camera's built-in flash or another system-compatible strobe is triggered directly by the camera, the off-camera flash fires, so long as the sensor is within sight of the first strobe and within the specified operating range. The disadvantage is that there may be restrictions as to how the slaved flash can be used. You usually must give up some features.

The option of using a conventional photo slave with TTL dedicated flash exists, provided it is via the standard PC socket (if available). However, the

use of an accessory slave defeats the dedicated circuitry and turns a TTL flash into a conventional strobe that must be operated and metered manually.

There is yet another option fresh on the horizon: a separate photo-slave device that attaches to an off-camera TTL strobe and maintains TTL performance. All it requires is the camera's built-in flash or an accessory TTL dedicated flash as the triggering mechanism. The slaved flash will fire, mimicking the output of the flash connected to the camera. Unfortunately, this option does not maintain many of the dedicated features, such as an auto-zoom flash head.

Note: In TTL dedicated automatic strobes that emit a pre-flash (for red-eye reduction or exposure determination), it is possible that the pre-flash might trigger the remote strobe. If this occurs, reset the camera or flash (as applicable) to an operating mode that eliminates the pre-flash.

While a number of TTL strobes provide a built-in slave sensor, many others do not. A wireless photo slave such as this, with the appropriate dedicated contacts, can be used to operate compatible strobes remotely, off-camera.

Photo slaves are available in a variety of shapes and forms. All these slaves provide a conventional sync contact for attachment to a standard PC cord. Beyond that, the slave device on the far left provides its own hot shoe for conventional hot-shoe strobes, thereby bypassing the need for a sync cord. Some photo slaves are truly tiny, such as the second from the left.

Multiple Lighting With Manual Flash

Multiple lighting with manual strobes takes several forms, all of which center around first setting the camera to manual exposure mode. One is where you can buy a multiple-flash connector through which up to three separate flash units can be connected to one camera PC terminal. Extension sync cords are required for all the lights.

The multiple connector itself plugs into the camera. Once all the lights are set up, position an incident-light flash meter at the subject position to take a flash-meter reading of all the lights. If you are using the flash in cord mode, which requires a hard-wired connection to the flash, remove the multiple connector from the camera and momentarily attach it to the meter to take the reading. Be sure to replace the connector in the camera's PC outlet to take the picture.

Caution: Multiple-flash connectors for conventional—that is, non-TTL dedicated—flash units pose a potential risk to the camera. Attaching several strobes, especially high-powered units, to one camera in this fashion may overload the camera's electrical contacts and short out the system.

Wireless Manual Flash Triggering

Another way to synchronize the firing of several flash units together off-camera is by wireless operation with remote-triggering devices. Slave-triggering devices can consist of a very simple photo-eye (photo-optical sen-

sor) or a more complex infrared or radio remote-triggering system. Wireless triggering requires two key elements: a trigger or transmitter and a sensor or receiver.

Simple photo slaves are sensitive to quick bursts of light, such as when a flash fires. Therefore, one flash unit connected to the camera acts as the transmitter. It triggers any off-camera strobes which have a photo slave attached. When you use one flash to trigger photo-slaved strobes, that first flash should be part of the lighting setup. The flash can be used off-camera with a sync cord for greater versatility. If it's on-camera, use it as a fill-light. To serve this purpose, the light should be weak enough so as not to overpower the main light. Otherwise reduce its output or redirect it so that the exposure and lighting scheme are not affected.

Infrared and radio receivers are not sensitive to white light. They require a transmitter that outputs invisible infrared light or a radio signal. The transmitter attaches to the camera by way of the hot shoe or PC terminal. Each remote flash then must be connected to a receiver to be triggered. Release the shutter at the camera and the transmitter signals each receiving unit to fire each remote strobe.

Unlike the simple photo slave, infrared and radio systems are not triggered by light from a flash. Therefore, they are preferred for situations such as weddings, in which other photographers will be shooting with flash. Some provide multiple channels. In this case, the transmitter will only trigger receivers in a lighting setup that are on the same channel. By using different channels, several photographers can use the same type of remote system in close proximity without triggering each other's strobes.

Close-Up Flash

The terms macro and close-up are often used interchangeably. Technically, they are not the same, but let's not overcomplicate our lives with over-blown definitions. Simply, let's say that close-up photography refers to magnifications of 1:10 (1/10th life-size) down to 1:1 (life-size). A macro lens brings you into the world of macrophotography with greater magnification ratios, usually life-size and larger. Although some photographers may dispute where to draw the line between the two terms, it's basically all close-up photography but to differing degrees.

Close-up photography requires certain tools to allow you to focus closer to the subject. These include extension tubes, bellows, macro lenses, and close-up filters. The close-up filter (also known as a close-up lens or plus-diopter) is perhaps the easiest to work with. Unlike some of the other

accessories, no exposure adjustment is required when a close-up filter is mounted on the front of the lens.

Without the benefit of TTL metering, an exposure adjustment is required when using extension tubes, bellows, and macro lenses to produce an image at or near life-size, because of the resulting light loss. This exposure adjustment, known as the lens extension factor, is often provided for the accessory in use. (If not given, the light loss can be determined by making test exposures of the same subject with and without the accessory.)

The difficulty with close-up flash photography goes beyond the loss of light. Subjects can be difficult to light because the lens-to-subject distance is shortened. The subject may be outside the line of sight of the auto-sensor on an automatic strobe (a condition known as parallax) unless the sensor can be repositioned more favorably. Moreover, auto-sensor and manual

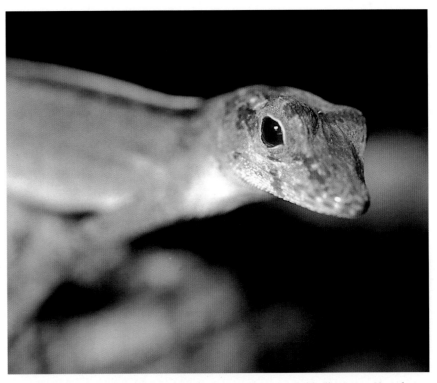

For this photograph of a lizard, a small, low-output flash was held off-camera. Note that there is minimal depth of field at this close range, just barely getting the eye in focus.

flashes were designed to operate only to a minimum distance of about a foot and a half, more or less. Bringing the flash in closer can result in erratic exposures. Because TTL auto flash takes all this into consideration, it may prove to be a less worrisome choice for close-up flash photography. However, subject to testing, both manual and auto-sensor strobes can be used with equal success.

At this stage, we're going to limit ourselves to close-ups within a foot of the lens. Anything beyond that point, when a telephoto lens combined with an extension tube or plus-diopter might be employed, should be ably met by the regular flash units at your disposal. Still, you might prefer these techniques even then.

There are several ways to effectively use flash with close-ups. Unfortunately, you can't use the built-in flash and very often not even an on-camera shoe-mount flash. In the first place, the light may shoot past your close-up subject, because the beam, even though it's spreading outward, is moving parallel with the lens. Compare this to traveling on two parallel roads that never meet.

To overcome this problem, some shoe-mount flash units provide a slight downward tilt that creates a converging pathway with the subject. However, this is not a surefire solution; the minimum flash distance is usually about 18 inches and the subject must be at least 10 inches from the lens.

At very close range, the obstacle here is the lens itself, which becomes an even greater obstacle with a lens hood attached. What happens is that the flash beam will intersect the lens barrel (or lens hood) en route to the subject. The result will be a giant shadow where light should have fallen.

Using a handlemount or shoe-mount strobe off-camera should help circumvent such obstacles posed by the lens. Handholding the flash or mounting it on a bracket allows you to position the flash toward the subject. You'll need to connect the strobe to the camera by way of a sync cord.

Shooting close-ups with off-camera flash provides numerous possibilities. It allows you to investigate the possibility of using soft lighting with a bounce card, miniature light bank, or small diffusion screen. Because these devices spread the light so that it covers a large area relative to the subject, they effectively become soft light sources under these conditions. This lighting largely eliminates harsh contrasts, so that no fill-light may be needed. However, it does reduce the illumination levels by which we're working. And that could be critical to a good close-up.

Macro-Bracket Lighting

Special macro brackets can mount two flashes units for higher illumination levels and more lighting control. The simplest bracket takes the form of a collar that fits on the front of the lens and holds two very small flashes. More versatile macro brackets mount to the camera by way of the tripod socket and also accommodate up to two strobes—but these strobes can be heavier and more powerful. The flashes are mounted on extension arms on either side, and these arms may be maneuvered to provide numerous lighting angles. One light can serve as the main light, while the second acts as a fill, or both can contribute equally to provide even coverage, side to side.

The increased light output that two strobes provide lets you stop the lens down for added depth of field. Depth of field is minimal for close-up photography to begin with. Stopping down as much as possible helps to keep more of the subject in sharp focus.

Calculating exposure for these dual-lighting setups need not be overly complicated. With TTL flash that maintains dedicated control in the camera, light output is determined by the TTL sensor. Auto-sensor strobes should be set to manual to simplify calculations.

With manual flash, calculate exposure for the main light and bracket. If both lights are positioned at the same angle and distance from the subject, and are of equal output, the second light adds 1 stop of light. Calculate the exposure for one light, and set the lens aperture 1 stop higher. An f/5.6 exposure calculation would be f/8 with these two lights. The same would apply to any setup with two lights at the same flash-to-subject distance contributing the same volume of light.

Ring-Flash Lighting

A popular approach to close-up flash lighting sidesteps the shoe-mount and handlemount strobes entirely in favor of a ring-flash. This is a circular flash tube that fits around the front of the lens with a power module that mounts to the camera's hot shoe. A cord connects the two components, and power is supplied by batteries inside the module. The on/off switch and other flash controls are located on the power module. This flash may also feature a focusing lamp, which is useful in low-light situations.

Another key feature of many ring-flashes is that the ring may actually consist of two or more flash tubes forming the entire circle of light. Each flash tube is individually controlled, so that one or more may be shut off. Power is shunted to the remaining tube(s), so the amount of light output by the flash is not diminished.

Why not use all the flash tubes? The circular configuration of the flash tubes produces a very even, very flat light. Turning off one of the flash tubes will produce a more three-

The simplest macro brackets attach with an adapter ring onto the lens, much like a filter. Two lightweight, low-output strobes mount onto this ring via accessory shoes. Each strobe can be independently moved around the circumference of the lens. Other lens-mounted macro brackets may be designed to accept only one strobe. The system illustrated is a TTL dedicated macro system. The two strobes are connected to the power module seated in the camera's hot shoe.

This butterfly hanging upside down was photographed with the dedicated macro bracket shown.

A ring-flash offers decided advantages when it comes to macro lighting. It can squeeze into tight spaces, past such obstacles as tree branches, although light output is limited. This TTL dedicated ring-light attaches to a module seated in the hot shoe. Two focusing lamps make hard-to-see subjects readily visible.

Lighting small, close subjects can be difficult. A ring-flash produces very even, very flat lighting that doesn't need to be repositioned each time the camera or subject moves.

dimensional rendering of the subject. By the way, despite what you may have heard about ring-lighting, it is not shadowless. When photographing an insect on a leaf, a curl in the leaf may block part of the flash head and cast an unwanted shadow. Shut off the flash tube that is blocked by the leaf in favor of the unobstructed side. The flash head itself rotates about its axis to accommodate such situations.

Because the ring-flash is mounted on the front of the lens, it goes where the lens goes. Tree branches and leaves that may block any other flash unit, even that on a macro bracket, are no obstacle for the ring-light. If the lens can see it, the ring-flash can light it. With its narrow profile, a ring-flash may remain attached to the camera, with less concern over bumping into things as you go down mountain paths or narrow passageways.

However, a ring-flash is not a powerful light. Guide numbers range from around 25 to 45, compared with guide numbers in excess of 100 on most popular flash units. That means you can't use these lights with conventional subjects, since the distance covered is severely limited. (Because the light is on-axis with the camera lens, this form of lighting may not be suitable with subjects prone to red-eye.)

Ring-flashes are available in TTL auto, manual, and auto-sensor models. With auto-sensor ring-lights, parallax will result in erroneous exposures when the subject is positioned closer than the minimum distance for which the flash was intended, normally a foot or more, depending on design.

To make a subject stand out against a dark background, use a small aperture and fast sync speed. This prevents ambient-light exposure and limits the flash range so its light doesn't reach the background.

This family portrait was actually taken with a portable strobe mounted on a light stand. An umbrella was attached to diffuse the light. Setting up the strobe was a tough call, since no modeling light was available.

This self-contained strobe comes with the main unit which houses all the circuitry, a flash tube, modeling lamp, and umbrella-compatible reflector. Other self-contained studio strobes vary to some degree but share this general concept, with a control panel on the back or sides. Because the unit is self-contained, it requires no external power supply—just an AC electrical outlet of suitable voltage. High-powered studio strobes may require 220 volts but others, such as this one, need only standard 120-volt household current.

Studio Flash

Monolights and power-pack systems

The familiar portable flash unit lacks one key feature necessary for a high degree of control over lighting: the modeling light. The modeling light is a tungsten, photoflood, or incandescent bulb that mimics the throw of the flash illumination and provides a continuous light source that we can readily see by. This lets us preview how light falls on the subject, which areas are highlighted, and which are in shadow. By the way, remember to shut the modeling lights off when shooting: It gets hot and uncomfortable under there, and it wastes electricity.

There are two types of studio strobes: self-contained and power-pack. The self-contained strobe, also called a monolight, has the flash capacitors and all controls built into the unit. Each self-contained flash head plugs directly into the AC wall

outlet and operates independently of every other self-contained flash head that may be used on a set.

Power-pack systems are the power-houses of the industry. They concentrate all the stored energy and many of the controls in one portable box. To this box are usually attached anywhere from one to four flash heads, which share the available power. Here it is the power-pack, and not the flash head, that plugs into the wall outlet.

Whether monolight or power-pack, a photo-optical or infrared slave is often a built-in feature on studio lights. Each self-contained strobe requires its own slave sensor, whereas one slave sensor is all that's needed for one power-pack to trigger all the attached heads.

Umbrellas and Softboxes

The photographic umbrella looks like any umbrella, except that it is lined with a highly reflective material, often satin white or silver. The umbrella attaches to the head of the flash unit in some fashion. A light-diffusion bank or simply light bank, which you may know as a softbox, also attaches to the flash head but is designed to give light a quality as if it were coming through a window sheer. Both products diffuse the light, only each does it in its own characteristic way and to differing degrees.

Umbrellas and light banks provide a soft, wraparound light that at the same time covers a much broader subject area than the flash head alone could do with its standard metallic reflector. The beauty of umbrellas and light banks is that they come in all sizes, even fitting our portable strobes.

The designs of umbrellas and banks for portable strobes may not be as fancy as the gear used with true studio lights, but often they work fine, within reason. There are a few things

you need to know, however, to make the most use out of any umbrella and light bank, small or large.

- The moment you attach an umbrella or light bank to a flash, the umbrella or light bank, not the flash unit, effectively becomes the light source. This then allows us to refer to an umbrella or a soft-box as a large light source.
- Umbrellas are often less costly than light banks and set up more easily and more quickly.
- For the umbrella or light bank to be a source of soft, wraparound lighting, it must be as large as or larger than the subject that it is lighting.
- For the umbrella or light bank to be effective, it must be positioned as close to the subject as practical. The farther you move the light source from the subject, the less diffuse and the harder the light becomes. The closer to the subject, the softer the light. (With umbrellas, be careful not to position the protruding shaft too close to your subject.)
- Combine the two previous factors—large light source close to the subject—to create the softest light source possible with the tools available.
- The interior of the umbrella and light bank contribute to the diffusion of the light. A satiny white produces the typical soft light effect, neutral to warm in color; silver produces a slightly harder light that may be tinged blue; gold-tone produces the same harder quality as silver but in a warmer, golden light useful as a color accent on one side of the face, for example, or for an overall warmer effect.
- Shoot-through umbrellas are less effective as soft light sources than bounce umbrellas, because

they tend to produce a hot spot— a clearly defined circle of light that fades very noticeably toward the edges, so that anything falling outside that circle receives considerably less light. Some trial and error may produce useful results with a shoot-through umbrella, however.
- Light banks may produce a hot spot, but owing to the size of the bank, the usable area is often sufficient to cover the subject. An internal baffle reduces or eliminates the hot spot on many soft-boxes and produces a more even light across the picture.
- Two or more light banks may be positioned side by side for a continuous sweep of light.
- The use of a photographic umbrella or light bank of any size results in a loss of light available for the subject. In other words, to get the same volume of light on the subject that you would have had without the accessory will require a more powerful strobe, or that more power, if available, would have to be pumped into the existing flash head.
- Umbrellas produce characteristic umbrella-shaped catchlights in the eyes, which some people find objectionable; softboxes produce rectangular catchlights that some find more acceptable.

Now that we know what they are, we still need to know how umbrellas and light banks work. We'll start with the umbrella.

Photographic umbrellas

Mount the flash on a light stand and then attach the umbrella. (Miniature umbrellas can be used with a portable strobe on a bracket.) The configuration is such that in order for the umbrella to be a bounce light source, the flash head is aimed into the

interior—the reflective surface, which is directed at the subject. Because the outside of the umbrella is an opaque material, the only way for the light to go is toward the subject.

On the other hand, a shoot-through umbrella (one that uses a sheer white material) takes the opposite approach. The flash is directed at the interior of the umbrella, as before, but this time the parabolic side is aimed toward the subject, following the line of sight of the flash head.

Light banks

A strobe routinely attaches to the softbox at the rear. Surrounded by the four reflective walls, it is practically encased inside this structure. The flash head faces outward toward the diffusion panel covering the front of the box, through which the light pours.

Small light banks are available for portable flashes. A few clever designs are even inflatable and attach to the flash head by elastic or adhesive material. Remember, however, that the small size makes it suitable as a soft light only for diminutive subjects.

Additional Light Modifiers

There are numerous other devices beyond softboxes and umbrellas to shape flash illumination. These include barndoors, snoots, and honeycomb grids. Because they narrow the beam of light down to a selected subject area, that makes it all the more important that such accessories be used with a modeling light that enables you to preview the lighting effect. Interchangeable bowl-shaped reflectors on many of these flash heads modify the light as well, shaping it to cover larger and smaller areas, with a harder or softer light, respective of the size, shape, and design of the reflector.

Barndoors, snoots, and grids attach in front of the flash head's reflector. Barndoors come in sets of two or four. As each door or panel closes in over the face of the flash head, it increasingly prevents the light from spilling out in that direction.

The honeycomb grid, so called because of its honeycomb pattern, is often used to imitate the effect obtained from a conventional spot light. While not exactly a replacement, this device, also known as a grid or grid spot, has the effect of redefining the beam of light into a tighter, more sharply honed circle of light than the reflector alone can deliver. The snoot, which is cone-shaped, gives you an even smaller, more well-defined spot. It is used to contain the light more and direct it at a specific area of the subject.

A set of barndoors is a practical necessity for a studio strobe to prevent light from spilling out onto other subject areas.

Collapsible reflectors are lightweight and portable with a variety of surface tones. The gold and silver reflectors feature a white panel on the reverse side. The white reflector can be used as both a reflector and as a diffuser. As a reflector, it is placed near the subject. As a diffuser, it is placed in front of the strobe head to soften the light. Within practical limits, the farther the diffuser is placed from the flash, the softer the resulting light.

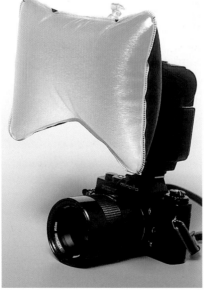

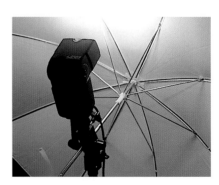

Portable strobes accept miniaturized versions of studio accessories. These include small umbrellas and softboxes, such as an inflatable mini-bank that attaches to the flash head.

A Basic Photo Studio

What do you need to put you on the road to success in studio lighting? While you can work with those portable strobes, you'll find they have one serious drawback: They keep you in the dark until the moment you see the results. They lack modeling lights that aid in judging the effect the lighting has on the subject. You might also find it's possible to buy an economical studio system that is less expensive than a handful of TTL dedicated strobes and all the accouterments that go with them. What's more, the widest range of light-shaping devices is available for studio systems from a variety of sources.

Every studio begins with at least two lights; three are better, along with an equivalent number of light stands. If you plan to constantly use one flash as a backlight, substitute a background stand (lower to the ground) for one standard-height model.

Start off with self-contained strobes: They're often less costly and easier to work with than power-pack systems. Moreover, operating multiple flash heads off one power-pack reduces output on each head, a problem you won't have with self-contained strobes.

Umbrellas are easier and quicker to set up than light banks and much less costly, so start with a pair of umbrellas: one white, one silver. Some white umbrellas have a removable black cloth backing. Remove this outer layer and you've got a shoot-through umbrella.

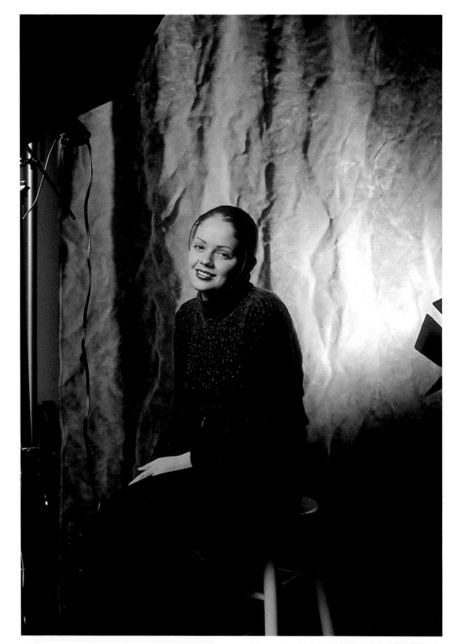

A starting portrait setup requires a main light and an umbrella (or softbox for more ambitious home studios). The umbrella is useful because it provides a nice, soft light that is fairly evenly spread across a number of subjects. Also, it is quick to set up and inexpensive. The softbox provides superior control and better lighting definition. While a portable battery-powered flash can be used, an AC-powered studio strobe with a modeling light is a better choice. The studio flash gives you a better sense of how the lighting affects the subject. Then add a second light, which can be used either for fill or as a backlight. Here an umbrella light provides the key illumination. The backlight adds dimension to the portrait and prevents dark tonalities from merging. The barndoors on this light serve to keep stray light from hitting the subject. You might position one of the barndoors to allow a little light to spill onto the hair—as a quasi-hair light, but some people might criticize that as a lack of lighting control. A fabric backdrop was added here as well.

Many studio strobe systems are sold in kits designed to handle a variety of jobs. You can start less ambitiously, but just consider a portrait kit, for example. This might consist of three lights (key, background, and fill) with built-in slave sensors, together with umbrellas, stands, cables, and other accessories—all neatly packed in a portable case for home studio or location work.

Aside from all that, you'll need a background. A white wall will do nicely. You can buy cloth at a fabric shop or poster-board at an art-supply store for variety. If you want to get fancy, try painted muslin—a studio favorite. Perhaps more popular is seamless paper, which must be bought in large rolls—half-width sizes are available. Graduated backdrops, with or without grids, and textured surfaces may be obtained commercially. Most backgrounds, except canvas and seamless paper, are easily portable. A handful of portable cloth backdrops are even supplied with their own carrying bag.

A background stand may be needed to support a muslin, canvas, cloth, or seamless-paper backdrop. Muslin is the one material that looks best when wrinkled—and should actually be stored that way. When hung as a backdrop, it is bunched up into gathers to create naturally flowing lines that add dimension to the picture, through the interplay of light and shadow, a result of sidelighting. Extending a lengthy backdrop into the foreground adds a continuous sweep that works very nicely to give the set a sense of continuity.

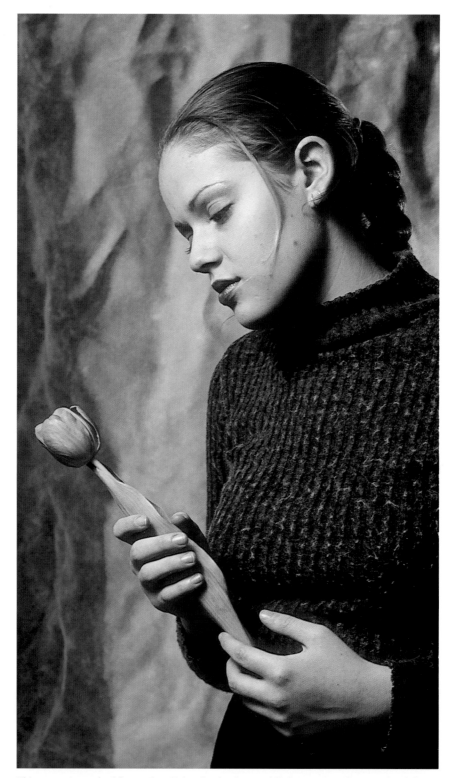

This portrait resulted from a key-light-plus-background-light setup, as illustrated at left, although the model was actually standing for this pose.

The Flash Meter

After a while, you may sense that the camera's metering system can't handle those more esoteric flash applications. It's one thing when all the strobes are connected to the camera's automatic flash metering system via a TTL dedicated hookup, or even working with one off-camera auto-sensor strobe.

It's quite another matter when you begin working with remote flashes that are not TTL-connected to the camera, even if each has an auto-sensor. Or when using colored filters on a manual flash, or several filtered manual strobes in combination. You'll find the camera has no way of measuring these difficult flash exposures.

At this stage, a handheld flash meter is required to expeditiously meter the lighting. The flash meter sports a photocell, and this cell reads all the light hitting it, regardless of the number of strobes involved.

The meter has a triggering button that is pressed to fire the flash manually, before the actual camera exposure is made. This lets you take the reading with the meter. The strobe is connected to the meter via a standard (non-TTL) sync cord.

Many flash meters will read the flash even without a sync cord to trigger the flash. In this case, known as cordless or wireless mode, when the measuring button on the meter is pressed, the meter remains in a ready state. The flash is then fired manually with the strobe's test button and the meter reads the light.

There should be no appreciable difference in the two readings—with or without the sync cord. However, individual flash meters may incorporate ambient light into the flash reading, particularly in sync-cord mode. This may affect the overall exposure if ambient-light levels are high.

Also, and this is very important, whether with a cord or cordless, readings made with a hot-shoe or handle-mount flash must be made in manual

flash mode, allowing enough time for the flash to recycle to a full charge. This provides a consistent flash output. For a studio unit, manual operating mode is a given. Set the camera to manual mode as well, along with the appropriate flash sync setting, to avoid any undue surprises.

Using a handheld flash meter does involve more than just pushing a button. As with cameras and flashes that require you to manually set the film speed, a handheld meter requires you to do the same. Older flash meters use a needle or digital LED (light-emitting diode) to indicate the light measurement. These require you to transfer the number from the meter reading to a calculator dial. This dial, which is similar to the flash calculator, then gives you the necessary *f*-stop at the applicable flash sync speed. This *f*-stop is then set on the camera.

Newer flash meters, like today's popular cameras, provide a direct digital LCD exposure readout. The display also shows the applicable operating mode: cord or cordless flash, or ambient-light mode (for continuous light, such as daylight or interior lighting).

The digital readout provides the *f*-stop necessary for a flash exposure at the flash sync speed set. Flash readings are made over a limited range of flash sync times, from 1/500 down to 1 second. The shutter speeds for ambient-light readings are usually much more extensive.

Incident- vs. reflected-light readings

All popular flash meters read both incident and reflected light, so the option is always there to use the meter for either type of measurement. What's the difference? Let's look at what comprises the typical flash meter.

To begin, the meter features a white plastic dome on its face, at the head of the meter. This dome covers the light-sensitive photocell and collects light

The handheld flash meter becomes a practical tool when manual flash is used, especially with multiple-strobe setups. Studio situations almost demand the use of a flash meter. This model happens to be fully digital, but some meters use a calculator dial or a digital LED, in place of the LCD panel shown here. The meter is shown with the incident-light dome in place, used when the meter is held at the subject position and its photocell directed toward the camera.

falling on it from all directions. As this light passes through the dome, it is read by the photocell, which then triggers the display, once the meter is activated. This is an incident-light reading. Removing the dome, or sliding it out of the way, reveals the photocell, which is now prepared to make reflected-light readings.

An incident-light reading is a reading of light falling on the subject. This reading is taken with the meter held at the subject position and with the white, light-collecting dome normally facing the camera.

Incident-light measurement is totally opposite from the way we're used to taking meter readings with the camera. The camera does not read incident light. It reads reflected light.

The advantage to taking an incident-light measurement is that subject

tonality and brightness do not ordinarily affect the light reading. However a reflected-light reading (one in which the meter or the camera lens is pointed at the subject and reads reflectance values, namely brightness or darkness) is easily influenced by those bright and dark tones and colors. Bright and dark colors, respectively, reflect more and less light than would a medium gray, or more specifically, an 18% gray tone. Consequently, with flash as with ambient light, the result is underexposure of light-toned subjects and overexposure of dark-toned subjects.

That doesn't happen with incident-light readings. The light that reaches the photocell has not bounced off your subject, but instead is coming straight from the same source that is illuminating your subject. While not as convenient as direct camera readings, this incident form of light measurement often proves more accurate.

Excessively light or dark colors may require a subtle adjustment in an incident-light measurement, however, to restore texture and detail. For example, a white wedding gown may come out pure white when the bride is metered with this metering method. The problem is that this exposure fails to capture the intricate handiwork that went into the gown. One-half stop less (not more) exposure would help restore that detail.

Which situations don't lend themselves to measurement by a flash meter? Close-ups within inches of the lens' front element are often not practical, especially of very small subjects. Another situation would be snapshots on the fly. You can't always stop the action to take a handheld meter reading. Parties and sporting events are both cases in which this is true.

As with any manual exposure measurement, lens extension factors and filter factors apply as well. Compensate the reading by adding the appropriate exposure factor to the *f*-stop determined by the meter.

An umbrella strobe provided the key lighting. To lower contrast, a collapsible reflector held by an assistant was added on the side opposite from the main light to fill in the shadows. Hidden from view is the backlight. This setup was used, with some modification, for the family portrait below.

Three generations posed for this portrait. The key light was placed higher than in the setup shown and at an angle that would more evenly illuminate the group, as measured by an incident-light meter. Despite that, it was still necessary to add a reflector at right. A backlight was also used.

Putting Flash to Work

We've got the tools and now it's time to apply them to lighting different subjects and situations. We begin with photographing people, working mostly indoors in a more controlled setting. Next we take camera and flash outdoors at night with a variety of subjects. We'll also see what is required to successfully copy documents. Finally, still life will challenge us to design a composition that is dynamic and multidimensional. In each case, we'll see how flash lighting affects the subject and how the subject influences the lighting.

Add a white reflector to bounce light from the flash onto the side of the subject's face that is in shadow. This dramatically reduces contrast. You may have to move the reflector around a bit to achieve the most advantageous lighting effect. A modeling light on the strobe is of immeasurable help in judging the lighting.

Portraiture and Portrait Lighting

When photographing people in a studio environment or in any place where you're controlling posing and staging lights, it's important to realize that your subject has three-dimensional form, that the human face is not round like a globe but faceted with a distinctive bone structure that may need to be accentuated to bring out that person's character. Similarly, other features or the clothing that person wears may need to be emphasized. In other words, don't automatically opt for a soft light when a hard light may be needed to catch those character-building features, even wrinkles.

Let's begin by lighting our subject with one light. We'll move the light around, perhaps soften it, and then add more lights—all to bring out the expressive nature of our subject.

There is more to light placement in portraiture than putting the light in front, to the side, or behind the subject. The placement of the light must also be combined with the proper angle to produce just the right shadowing and contrast. Often our chief concern is lighting the face. The rest tends to follow, although the hands may be important when they are displayed prominently. Studies of the human form focus on lighting to emphasize contours and shapes.

Begin by positioning the subject several feet from the backdrop. This prevents the subject's shadow from falling on the backdrop and appearing in the picture. What's more, if you later add a backlight, this will help keep that light from spilling over onto the subject.

For a conventional portrait with the subject looking straight into the camera, begin by placing the light above the subject's level, angled 45 degrees downward and off to one side at about a 45-degree angle relative to the subject, so that the light is not coming from directly in front. This type of light will produce the traditional contouring of the face, highlighting key features. One side of the face is fully lit, while the other side is largely in shadow, except for a triangular patch of light beneath the eye extending down to just above the lips, primarily covering the cheekbone.

Next decide whether to broaden a thin face or make a round face appear more narrow. Turn the face away from the light and the light appears to illuminate more of it, making the face fuller and rounder. Turn the face toward the light and a triangular patch of light chisels the features, accenting cheekbone structure, creating the appearance of a thinner face.

So far we've been working with the light unmodified. Add an umbrella or softbox and see how the lines that distinguish light from shadow begin to blur, and note that the shadows become less intense. Take the opposite approach by adding a honeycomb grid. This produces not only a harder light with deeper shadows, but that light defines a smaller portion of the face.

In portraiture, the key light—the main light providing the principal illumination on the subject—is often used with an umbrella or softbox. Adjust the position of the light—up, down, at different angles—to see how it affects the subject.

The subject's facial features may dictate the lighting. If there are facial blemishes, put that side of the face in shadow. The light can also be angled to tone down a prominent feature. Another trick used to hide imperfections is to overexpose a portrait slightly so less detail shows up in the photograph.

Now let's see what a backlight will do. Shine a light at a white backdrop. This now helps separate the subject from the background. You'll need to control the spread of light, perhaps

A studio strobe, positioned to the right of the camera, threw a hard light at the subject from an oblique angle. The light remained stationary while the subject was asked to pose looking straight into the camera (photo top), and then to turn his head left (middle) and right (bottom). Notice how the position of the head affects the way the light strikes the face.

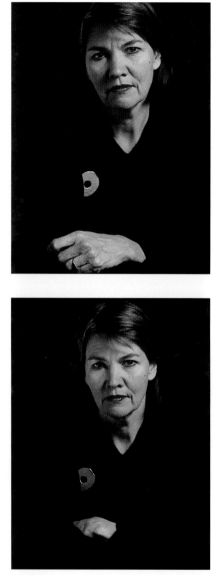

An umbrella has been added to the strobe to soften the light, but its angle and distance from the subject still produces considerable contrast. A reflector was added to help lower contrast. The white reflector worked nicely (photo top), but a gold-tone reflector provided even more fill (photo bottom). The metallic gold surface gives the subject a slightly warmer appearance as well. Notice how the spread of light from the strobe with the umbrella also reaches the backdrop. Bringing the light closer would spread it out even further.

with barndoors. The light can be positioned from below, on a background stand, or from the side. This creates a graduated background, from white to gray. Add a filter over the light, and it produces a graduated color backdrop.

If you only have two lights to work with, the key and backlights are a good starting point, especially if the main light has an umbrella or softbox. On the other hand, a fill light could be more beneficial than the backlight if the contrast on the subject is too high.

With only two lights, assigning a hair light is not a priority. Adding a hair light requires a third light, or even a fourth if lights are used in the main, background, and fill positions. Adding dimension to the portrait while enriching the hair with luster and sheen, the hair light could be a flash head with a snoot, striking the hair at a glancing angle from above and behind. Another approach uses a small softbox (not an umbrella) that is positioned overhead, angled slightly from behind the head.

Portraits of couples and groups

Keeping in mind that the size of the light source must fit the job, a full-length portrait of an individual or couple will require proper light coverage. If the umbrella is not large enough, it may need to be moved back a little to cover that area, even though increasing the distance may reduce the light's softness just a bit. A softbox will have to match the subject size more closely, because this light is tighter and does not spread out the way umbrella light does. The light bank should be positioned vertically to match the dimensions of the subject, horizontally for a head-and-shoulders portrait. With couples, watch that the light is even across both people. In any event,

be careful of light falloff. Contrast measurements with an incident-light meter would help.

A less-formal group shot could make use of one flash on-camera—preferably on a bracket extending above camera level, with a second light held aloft on an extension pole, somewhere in the crowd. Usually, an assistant will be holding the second strobe, which is slave-synced to the first.

If you're working alone and stuck with only one handlemount or even a shoe-mount, detach the flash completely from the hot shoe or bracket and raise it up as high as you can, tilted downward toward the crowd. This will increase coverage. Other options include spreading the light with the wide panel or wide zoom position, or using bounce flash.

Portraits of children

Youngsters tend to be rambunctious and don't like to sit in any place for too long. Lighting should always be set up and ready to use, only requiring some tweaking once the subject arrives. Children won't wait and will lose interest while lights are set up, unless their mother can keep them entertained. Have plenty of child-safe toys on hand or ask the parent to bring some, especially the child's favorite. Keep the photo session short and take frequent breaks. If the youngster appears disturbed by the flash, stop using it.

For an infant, diffusing the flash will wrap the child in a soft, gentle light. A softbox or umbrella will provide the needed light quality, as will bounce flash off the ceiling or a nearby wall. The lighting setup for an older child can be the same as for one adult. When putting more than one

child on the set at the same time, consider using two lights—one on the left and the other on the right. This will cover the kids no matter where they stray on the set. Umbrella lights positioned from in front and at a 45-degree angle to the kids should work well. Because the light from a bank is more restricted, using two light banks might not cover both kids over a large studio area or even in a spacious living room. To keep wires from getting in the way, slave-sync the second light.

When photographing kids playing outside, don't rely on the built-in flash. Its recycling rate is too slow. By the time the flash is ready, you may have missed countless moments. Instead, use a shoe-mount or handle-mount with auto-sensor or TTL auto capability, for spontaneity. Don't forget to use fill-flash with bright daylight whether in the backyard, a playground, or on the beach.
Caution: Babies' and toddlers' eyes may be more sensitive to the light than older kids'. Don't pop a high-powered strobe directly in or close to a baby's eyes. That should not be done with adults, either. Keep the light back a few feet and reduce its intensity as far as practical.

Action portraits

Indoor sports are ideal for flash photography. With permission you may be able to set up one or two lights off-court and trigger them remotely. Because other people may be taking flash pictures with point-and-shoot cameras that will trigger any flash connected to a photo-optical slave, use an infrared or radio remote. Test the remote device before the action begins to avoid unpleasant surprises.

Many action photographs will simply have to utilize on-camera or

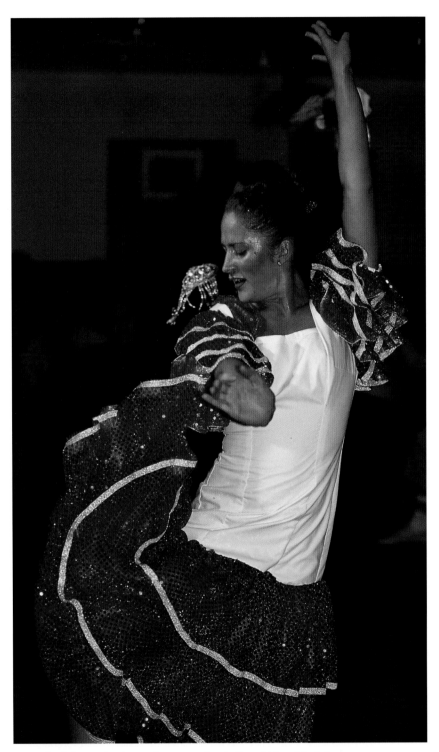

Using flash freezes motion and captures the vitality of this spirited dancer.

bracket-mounted flash. When taking group photographs or pictures of a solo performer posing for you, follow simple guidelines: Try to use bounce flash or other soft lighting if restricted to one light, although a hard light from off-camera builds character; watch for reflections off eyeglasses and backgrounds; and avoid red-eye. And work quickly.

Stage lights, especially spotlights, will fool the meter into underexposure, but that is the beauty of today's computerized exposure systems: The camera should read the subject and background and provide the optimal amount of flash illumination. Unfortunately, you can't know this in advance, and a trial run is in order. An excessively dark stage surrounding a spotlighted actor might result in overexposure, requiring you to give less exposure than recommended by the meter. Spot metering tightly on the performer in the spotlight is appropriate here.

If you can't get in close enough and have to use a telephoto lens to get that tight shot of a player or a person on stage, make certain to set an *f*-stop large enough to deliver the light the necessary distance. With a telephoto lens on the camera, check that the strobe's zoom is set to telephoto or use the tele attachment panel.

Finally, freezing movement all the time takes something away from action portraits and will leave anyone who looks at these pictures cold after a time. Consider adding some blur by shooting at longer shutter speeds than that required for simple flash sync. These will truly be your moving images.

Flash Outdoors at Night

Remember that flash outdoors, away from the walls and ceiling of a room, loses a portion of the light on which the guide number is based. In effect, the flash is now less powerful than it was indoors. Fortunately, TTL dedicated systems and auto-sensor flash can read the light that is actually reflected off the subject, so the exposure should be reliable. With manual flash, there will definitely be a problem. With these strobes it's often necessary to open up 1 stop and bracket. Subjects within a few feet of the flash may not need exposure compensation, but bracketing always helps.

Illuminated statues, fountains, and monuments make striking subjects for outdoor flash photography at night. With people, you'll need to invoke the red-eye reduction mode when using the built-in flash. Ordinarily, a flash seated in the hot shoe, and certainly on a bracket, should not produce red-eye but it can and does happen.

You can create some startling pictures. A subject standing against the darkness creates a dramatic effect. Off-camera flash at the proper angle will add modeling and dimension to the subject. Set an *f*-stop that carries the light only as far as the subject to avoid lighting the background.

Flash With Pets

Pets don't seem to mind flash, especially if they've grown up with it. However, always be alert to signs of discomfort. On-camera flash, or even built-in flash, is the most expedient choice with many animals, but you may notice distracting background shadows. With built-in flash be sure to use the red-eye reduction mode. Better yet, use the shoe-mount or handlemount—aimed at the wall or ceiling for bounce flash where possible.

For a studio portrait, set up an off-camera flash with an umbrella or light bank. A white poster-board reflector on the side away from the light will help to bounce back some light and fill in shadows where they may occur. Find an appropriate backdrop—a nicely upholstered sofa will do for a cat or dog.

Smaller pets such as hamsters, gerbils, or any animals that cannot be relied upon to stay within a confined area should be photographed while being held by the owner or while in an enclosure. Otherwise, more time will be spent chasing after the animal than photographing it.

Flash with pet birds

Birds outside the cage are often as tame as any cat or dog, but since no one can predict how an animal will respond to flash, proceed slowly. Birds are more easily distressed than are larger mammalian pets. Stop using flash when the bird shows signs of stress. At this point it might even respond negatively to the camera itself, so move the camera away and give the bird a few moments to relax. If the bird continues to react after camera and flash are reintroduced, stop taking pictures altogether.

Photographing a bird inside a cage can present a problem if the flash will glint off the wire bars. To overcome such barriers, use the flash off-camera, held at an angle to the front of the cage or at one side of the cage, or find a surface to use for bounce lighting.

Cage wire creates a distracting element in the picture and is a potential problem for an autofocusing system. Ideally, photograph the animal through an open cage door. That, however, is not always practical. If necessary, focus manually and position the lens reasonably close to, and squarely facing, the wire grill. A large

f-stop will further aid to selectively focus on the bird and throw the wire out of focus. A short telephoto lens is preferable—especially if it's a 90mm or 100mm macro lens, or an 85mm with a plus-diopter to bring you close, but not too close. Watch for the background wire as well as the wire in the foreground, and try to throw both out of focus. The background will invariably be noticeable to some degree, however.

Caution: Do not position the lens too close to the bird, within reach of its beak, as birds may peck at a reflecting surface. The same applies to positioning the flash. Leave the animal some breathing room.

Pets in aquariums and other glass enclosures

Dealing with glass enclosures is not that much different from dealing with wire cages. Disregarding goldfish bowls as an impractical environment photographically (and as a habitat), we'll focus our attention on conventional rectangular enclosures.

Glass obviously kicks back reflections right into the lens. Working in a darkened room may help but is not entirely necessary with the technique outlined here. Position the lens squarely, right up against the glass. Avoid tilting the lens, since that may distort the image—thick glass may act as its own lens. The only reflections you then have to worry about come off ornaments inside the enclosure, the background glass, and possibly the animal itself. Some fish are highly reflective, and when lit squarely, their scales throw off a glaring hot spot. Their eyes also seem to glaze over.

There are several ways to light an aquarium or terrarium. The simplest requires that the flash be removed from the camera and positioned off to

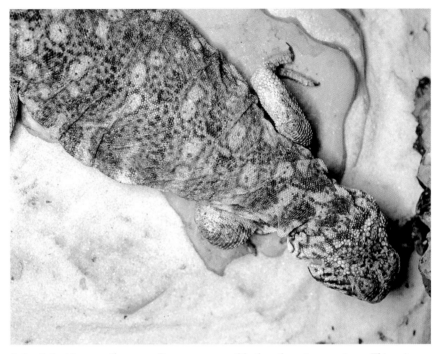

Animals inside terrariums are often more accessible than those in aquariums. This spiny-tailed lizard was photographed with a ring-flash. Shooting it from this viewpoint reveals a color pattern that would not be apparent at eye-level. The greater camera-to-subject distance, combined with the horizontal pose of the lizard, contributed to a fairly sharp picture along most of the animal's length.

the left or right, angled inward so the light hits the subject. A twin-arm macro bracket can be used to position two flashes on either side of the camera so that one acts as a fill light for the other when an animal wanders closer to one than the other. Similarly, work free of the lights and mount each on a separate light stand or tripod, or mount the macro bracket on a tripod. This way when you move, the lights remain in a fixed position. The only drawback to this frontal-lighting approach is that the back glass may pick up reflections from the strobe.

With terrariums, as well as glass-covered aquariums, you can also position the light overhead, although this may cast deep shadows on lower parts of the animal. If the terrarium or aquarium uses sand or light-colored gravel as a substrate, the sand or gravel may serve to kick back some light to fill in those shadows to some degree. Overhead lighting provides a more natural and more dramatic form of light.

Because a tripod may not permit the lens to come right up against the glass, it's often best to hand-hold the camera. Once in position, don't move the camera around because you may scratch the glass. Use a plastic or rubber lens hood to further prevent scratching, which is especially a problem with acrylic environments. You

can also use the pinkie of the hand supporting the lens to feel the glass to avoid bumping into or scratching the surface with the lens. When you've found the ideal spot, ease the camera against the glass.

Caution: Do not place a flash over an aquatic or semi-aquatic environment where there is a possibility that droplets will form on the flash or where water may splash onto the unit. Each strobe carries high voltages and there is a danger of severe electrical shock, possibly combined with an exploding flash tube and shattering glass if moisture or water enters the unit.

Flash at the Zoo

Aside from the fact that zoos may restrict the use of flash around some animals, you are normally free to use strobe lighting. Common sense should dictate that you avoid flash with any nocturnal animal (those with large, wide-open pupils) and with any animals that appear skittish. That said, flash at the zoo is not much different than with other animals at home. Yes, these habitats are larger and you can't ordinarily get as close, but the same rules apply. As a rule, light stands and tripods are out of the question. At best, you'll have to hold the flash in one hand while your other hand operates the camera.

Bright backgrounds can fool your meter and cause your subject to be underexposed or silhouetted. Bracket exposures where possible, but if brightness is a problem, add 1 stop to the ambient-light exposure with auto-exposure compensation. TTL auto fill-flash should add an exciting dimension in these situations.

Using flash can have distinct advantages when photographing captive animals. By limiting the flash range to prevent background illumination, distracting elements, such as cage bars, are not apparent.

Know your flash unit's maximum distance. Many subjects will be beyond the strobe's reach. In these cases, conserve the batteries and use available light, or wait patiently until the animal comes in closer. The size of the enclosure and the proximity of the creature should dictate whether to use a small *f*-stop to focus attention on an animal nearby or a large *f*-stop to capture it at a distance, by restricting or extending the throw of the strobe light, respectively.

If bars or wires get in the way, use a telephoto lens and wide aperture to throw these elements out of focus. Unfortunately, the bars (or heavy mesh wire) may cast shadows on the animal. Try to aim the lens between the bars of the cage, from a safe distance. Also, watch for tree branches and other obstacles within the animal's environment that may throw a shadow on your subject.

Flash at the Marine Aquarium

Only deep-ocean creatures are sensitive enough to light to prohibit strobe usage around them. Here, as at the zoo, light stands and tripods are understandably out of the question. However, you may be able to move right up to the glass fronting many enclosed environments. That makes it possible to apply the techniques discussed for home aquariums and terrariums.

Be especially careful not to fire the strobe directly into the water from

Electronic flash produced this stark, three-dimensional rendering at a marine aquarium. Harsh light from the flash unit caused the deep shadows, and a small f-stop was used to limit the reach of the light.

on-camera. As underwater photographers have learned long ago, minute debris floating on the water reflects the flash illumination, making it seem as if you'd popped the strobe in a dirty mirror. Underwater photographers use the strobe on a bracket a fair distance from the lens. You can simply hold the strobe in your hand, a foot or more from the lens, and close to or against the glass at an angle toward the fish.

Copying

Copying simply involves laying a document or artwork down flat and photographing it. Owing to the small size of many subjects, close-up capability is often required. While it helps to use a special copy stand designed for this purpose, it's not necessary. White, gray, or black poster-board provides a simple backdrop. To keep a document flat, you may need to weight the edges. If necessary, lay a

clean sheet of clear glass over the document or artwork to keep it flat and use a polarizing filter over the camera lens to reduce glare.

Two flash units are needed for even lighting across the document or artwork. They are either both hardwired to the camera or the second is slave-synced to the first by way of a photo-optical or other slave-triggering device. In this initial setup, each flash should be set to manual mode, with

the camera in manual as well. Mount each flash separately on its own table-top tripod or on a short light stand that extends perhaps a foot to a foot and a half above floor level.

Set each flash so that the lights are far enough apart to make room for the entire document, with enough room for the camera to peek in. Angle the heads to spread the light evenly across the space to be covered, checking that they are parallel to each other and at right angles to the camera.

For small subjects, a macro bracket with articulated arms to hold each of the strobes can be useful. This setup can even be used with horizontal copying. Mount the bracket on a tri-pod and continue from there, follow-ing the general guidelines in this sec-tion. While the camera will still have to be aligned with the artwork and the lighting kept as even as possible, this may be a more convenient arrange-ment overall.

To make the light as even as possi-ble, consider using a small light bank on each flash head. Alternatively, attaching a light diffusion panel or setting the head to the wide zoom position may work well. Either way, it's still necessary to take light mea-surements across the entire subject to verify that the lighting is indeed even.

Place a KODAK Gray Card over or in place of the work to be copied, and with a reflected-light flash meter, take readings across the entire subject area. An incident-light flash meter can be used without the gray card but preferably if the dome can be replaced with a special flat disc used for this purpose.

Use the flash meter to check that the lighting is even corner to corner, edge to edge. Note any hot spots or areas receiving too little light.

Anything more than a half-stop devia-tion should be corrected by readjust-ing the flash. Some might even con-sider that too much. Adding a white fill-card near the edge or corner receiving insufficient light, or a black card to absorb excess light, may prove helpful.

Make certain the material does not appear skewed by mounting the cam-era squarely on the underside of a tri-pod. A right-angle finder adapter (attached to the camera eyepiece) will make it easier to see the image at this point. A bubble-level will help you judge if the camera is level. Finally, check alignment through the viewfinder. If alignment continues to be a problem, consider a tighter view-point, one which eliminates the skewed edges. Sufficient light should let you stop down to a small lens aperture which would extend sharp-ness to all subject planes, in the event that the subject is not perfectly flat either on its own or due to camera alignment problems.

Take a reflected-light flash meter reading of the gray card. Or, without the gray card but with the white dome back on the meter, take an incident-light flash meter reading. Set the exposure on the camera. Bracket in half-stops up and down—that is, make the first exposure as per the meter reading, then additionally expose at +1/2 , +1, +1-1/2, -1/2 , -1, and -1-1/2. Since you're using flash and bracketing in half-stops, make all exposure adjustments in *f*-stops. The bracketing may be totally unneces-sary, but a little more or less exposure might help to bring out the true tonali-ties better or highlight certain details.

If you use TTL flash, the handheld meter is still necessary to verify that the lighting is even. This again

requires the flash first be set to manu-al mode. After that, you can use TTL auto flash with the camera in automat-ic mode to make the actual exposure. Since you won't have the benefit of the gray card during the automatic exposure, it may first be necessary to adjust the exposure on the plus or minus side if the subject is excessive-ly bright or dark, and then bracket.

Caution: There are federal restric-tions that make it illegal to copy cer-tain government-issued and other legal materials. These restrictions apply to, among other things, money and other legal tender, legal docu-ments, and stamps. It is also illegal to copy any copyrighted material, including original works of art and photographs created by others, with-out expressed permission.

Still Life

Still life is a constructed design, sometimes complex, other times sim-ple, and an art form in itself. We have all seen photographs and paintings of flowers in a vase, bowls of fruit, and countless other still lifes. Very often the still life is fabricated in the studio, but many times it is found in pleasing arrangements of leaves on a branch, fruits colorfully arranged in a farm-ers' market, or in any number of situa-tions. For some, creating a studio still life comes naturally. For many others, it takes a practiced eye, time, and patience.

The setting and subject determine the lighting. Modeling lights on studio strobes are a definite asset. An over-head light bank works well with solid objects. Position the bank a little to the rear of the set, giving the light a chance to wrap around and define the

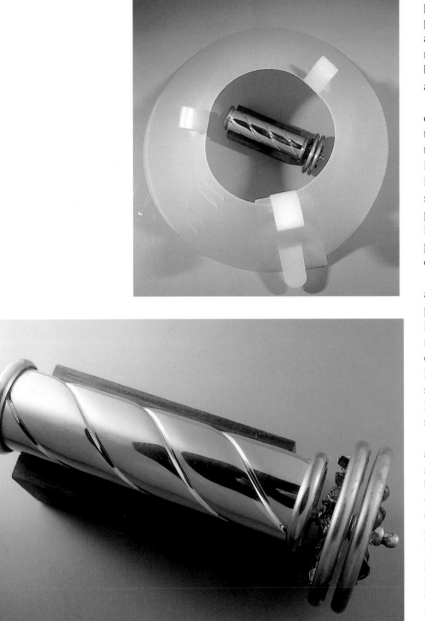

subject. A fill-light or fill-card will probably be needed at the front. When positioned at the proper angle behind a clear glass surface, the softbox's reflection will provide a clean white backdrop for a tabletop set. Add lights as needed beyond this point.

A very simple yet effective backdrop consists of a sheet of white poster-board, either flat or sweeping up toward the rear. A softbox or umbrella light positioned from a high position in front and to the side, with the possible addition of a fill-card on the opposite side, should work nicely. More interesting variations include color poster-board, graduated color backdrops, and draped cloth backdrops.

Small, highly reflective items, such as coins and jewelry, might need to be photographed inside a light tent, which is a conical or dome-shaped structure made of a translucent material with an opening at the top for the camera. The lighting setup can be similar to a copy setup, or it could just consist of one light. The light tent diffuses the light, spreading it across the entire subject.

Found still lifes may not permit anything but the simplest of flash setups. You can use on-camera strobe, but keep in mind that reflective surfaces will bounce light right back into the lens causing a glaring hot spot. If possible, use flash off-camera. The lighting angle and placement may have to be further refined beyond this point, depending on the subject's relative angle to the camera and its surface characteristics. For example, a glancing light may be needed to bring out surface texture.

With any tabletop setting, the subject may demand more attention to lighting than we're giving it up to this point. Aside from positioning the individual still life elements into a pleasing arrangement, learn to see how the light and the subject interact.

A light tent is ideal for shooting highly reflective objects. Commercial light tents are available, or they can be made from flexible translucent plastic or cloth stretched on a frame. As is apparent from the double shadows, two strobes were used, positioned to the left and right of the tent. The lights highlighted each key aspect of the kaleidoscope. Exposures were made with TTL auto flash.

Electronic Flash Troubleshooter: Common Problems and Practical Solutions

The following troubleshooting guide should be reviewed before a problem occurs, but in the event that you still encounter difficulties, refer back to it for the probable causes and recommended solutions. While it doesn't cover every contingency, this guide does tackle many different situations.

Before we begin, make it a habit to do the following each time you put the camera and flash back in your gadget bag:

(1) Check the flash unit and camera settings. Reset any functions, such as exposure compensation, that have been changed during recent usage. This will prevent you from accidentally using an operating mode that was previously set. Keep in mind that switching the camera off may not reset these functions. When shooting in the spur of the moment, this is one of the things that can easily be overlooked.

(2) Turn the camera and flash unit off to preserve battery life, and keep fresh batteries on hand.

(3) If the flash unit fails to work despite all your best efforts, send it in to an authorized repair facility. Do not attempt to fix it yourself. Do not leave it in disrepair in your camera bag. Take care of it now so you'll have the flash unit available when you need it.

Problem

Cause

Solution

Aperture or shutter value blinks in the camera's viewfinder with TTL dedicated flash.

This indicates potential over- or underexposure of subject or background. Consult the camera and flash unit's instruction manuals to define what a specific blinking value (aperture or shutter speed) may mean.

Adjust the blinking value upwards or downwards until it stops blinking. (Use the flash confirmation signal as a final check for correct subject exposure after the flash has fired.)

Auto-sensor automatic flash pictures are poorly exposed.

(1) Flash was set to the wrong operating mode.

Set the correct flash mode.

(2) Wrong ISO or distance was set.

Make certain that ISO is correctly set on flash calculator. Check that you are correctly matching up the distance with the *f*-stop on the flash calculator. Check that the display is in feet (or meters) to match the distance scale on the lens.

(3) Wrong f-stop was transferred to the camera.

Check that the *f*-stop obtained from the flash calculator was transferred to the camera.

(4) Subject or background was excessively light or dark.

Compensate for excessively bright subjects or backgrounds by underexposing, adding 1/2 to 1 stop of exposure. Compensate for unusually dark subject tones by overexposing, subtracting 1/2 to 1 stop of exposure.

(5) Subject was out of range for the selected f-stop.

Did you check the flash-confirmation signal before making the exposure? Move the subject within auto-aperture range or bring the flash closer to subject; otherwise, use an *f*-stop that will cover the applicable flash-to-subject distance.

Auto-zoom head fails to set zoom position automatically.

Flash head is tilted or swiveled, possibly resulting in a nominal zoom setting (under the strobe's computer control).

On tilt-swivel zooming flashes, set the flash head to its original forward position. Manually set the zoom head to the desired position for bounce flash.

Blue color cast when using strobe.

Strobe is emitting UV and blue light.

Use a skylight filter and, in more serious cases, an 81A or 81B warming filter.

Blur plus frozen moment (when undesired as an effect).

The subject moved during a slow exposure, or camera movement is also a possibility.

Check that the camera is not automatically setting itself to a slow-sync mode with flash, which uses long exposures under low-light conditions. Reset camera to program mode, which should prevent blur under normal circumstances. Also, check that you haven't set a long shutter speed. If applicable, set the camera's custom function to automatically use the fastest allowable flash sync speed under all lighting conditions (this may only apply to selected operating modes). Set the camera on a tripod during slow-sync flash photography.

Blur precedes movement in long exposures.

Camera was set to first-curtain sync, meaning that the flash pops at the beginning of the exposure.

Set the camera or flash to second-curtain sync (if available).

Built-in flash fires when not wanted, or available-light pictures show evidence of flash exposure.

Built-in flash was left on or not retracted into its off position, or the accessory flash attached to the camera was left on. Also, on select cameras, the built-in flash is automatically activated when the camera's light sensor detects insufficient existing light, to prevent camera shake. Moreover, setting the camera's built-in flash mode to the fill-flash setting will automatically activate the flash, even at inappropriate moments. Beyond that, the built-in flash may fire together with an off-camera, manual flash that is X-(wire-) synced to the camera, leading to foreground overexposure and secondary shadows.

Make sure that the built-in flash is fully seated, retracted, and/or turned off and that no other flash is connected and turned on. Watch for the flash-ready signal in the viewfinder, which indicates that a flash is active. Most cameras with automatic flash provide a means to prevent or bypass automatic flash activation in situations when it is not wanted, such as when the camera is mounted on a tripod for a long exposure. Other than that, check to see that the camera's built-in flash mode is not set to the fill-flash setting. If it is, reset it to Off or Auto. *Note: Turning the camera off and then back on may reset the built-in flash to automatic activation mode.*

Built-in flash pictures are too dark or subject is underexposed.

(1) Flash was obstructed.

Be careful to keep your finger, neckstrap, and other obstructions away from the flash.

(2) The flash-to-subject distance was exceeded.

Move closer to the subject or bring the subject closer to the camera, whichever is practical, after first checking that the flash will adequately cover the subject distance at the film speed in use. In situations when you're working with a camera on which the *f*-stop is under your control, set the lens to a larger aperture to accommodate the increased distance. Check flash confirmation signal on flash or in viewfinder (as applicable).

Close-ups: Exposure error with auto-sensor automatic flash.

Automatic flash sensor experiences parallax (subject is out of sight of sensor) if flash is positioned too close to the subject.

Move camera and flash back so that the flash distance is not closer than the minimum recommended distance for auto-sensor operation. A longer focal-length lens with close-up capability may be required to add distance between the flash and the subject.

Close-ups: Light fails to cover subject.

Flash head was aimed past subject.

With shoe-mount strobe, use downward tilt on flash head, provided this function is available and assuming the lens does not block the light path. Or remove the flash unit from the hot shoe and use it off-camera with a sync cord, making sure to point the strobe at the subject.

The tree was noticeably there to the right, but the camera was held in such a way, vertically with the on-camera flash on the right side, that the tree trunk blocked the strobe light from reaching the subjects. While this situation was contrived, leaves and branches prove to be more subtle obstacles.

Close-ups: Shadow falls on subject.

Lens (or lens shade) is too long or too wide for the built-in flash or possibly even a shoe-mount strobe and blocks all or part of the light, casting a shadow on the subject.

If a lens shade is the culprit, remove it from the lens. Switch to a shorter or narrower lens (if practical). Switch to an accessory off-camera strobe or a ring-flash.

Cluttered background.

Too much light is reaching past the subject and falling on the background.

Use a small *f*-stop and the fastest allowable flash sync/shutter speed. Or reduce flash output to limit the light's reach to the subject and thereby avoid lighting the background.

Dedicated flash functions are not fully operational.

Flash unit was not designed specifically for use with that particular camera model.

Flash functions are limited when a flash unit is used with camera models other than those that the flash was specifically de-signed for. Therefore you should buy the camera or flash specifically designed to deliver the camera's full range of flash capabilities, or live with the limitations.

Flare with off-camera flash.

Strobe is aimed in the direction of the lens.

Use a lens shade or, better yet, a black card (near the lens) to block light from hitting the lens; or redirect light away from lens.

Flash fails to fire.

(1) Flash was not turned on.

In the spur of the moment, this is easy to forget, so turn the flash on for the next shot, and hope something came of the available-light exposure anyway.

(2) Flash had not fully recycled.

Check the camera's viewfinder or the flash for the flash-ready signal before shooting.

(3) Batteries are exhausted.

Replace with fresh batteries.

(4) Faulty hot-shoe or sync contact.

Shut strobe off, remove from hot shoe, and reseat it, making sure to slide it all the way in. Then turn it on. Check the sync contact or sync cord for loose connections or damage.

Flash fails to fire after rapid-fire sequence.

(1) Flash was used beyond its recommended duty cycle.

Shut the flash off for a few moments, then turn it back on. If it works, the internal circuitry kicked in to prevent damage. If it doesn't work, the unit may be burnt out.

(2) Batteries are exhausted.

Replace them with new batteries.

Flash fails to fire with autofocus camera.

Camera failed to lock focus on the subject, which prevented the shutter from releasing.

Switch to manual focus or set an autofocus mode that bypasses this fail-safe mechanism.

Flash fails to provide TTL auto operation.

Flash may require the appropriate TTL auto setting to be set on the flash, and/or the camera may need to be set to a specific automatic mode.

Check that the TTL auto mode is set on the flash, and check that the appropriate mode is set on the camera.

Wait for the flash to recycle. Otherwise, you may get something like this, especially after moving the camera while impatiently waiting for the exposure to end. The electronic TTL flash-compatible camera reverted to available-light mode in the interim and that meant a long exposure.

Flash fires at the moment the unit is connected to the camera or flash meter.

When the flash unit is on, electrical contact at the hot shoe or sync terminal may trigger the flash.

Turn the flash unit off before mounting it onto hot shoe or making sync cord connections, whether to the camera or a hand-held meter.

Flash indicators are extinguished and LCD panel is blank, but the unit is switched on.

(1) Flash unit is in standby mode.

The flash should come on as soon as you press the shutter release down halfway or press the test button.

(2) Batteries are exhausted.

Replace them with new ones.

Flash meter fails to respond or does not respond correctly when the activation button is pressed.

(1) Meter is not set to the appropriate operating mode.

First check that the meter was set to the proper operating mode. A lightning bolt usually represents *cordless* (or *wireless*) mode. In cordless mode, no sync cord is used, and the flash must be fired independently of the meter. A lightning bolt joined by a *C* tells you the meter is in *cord-acti-vated* (sync cord connected between strobe and meter) mode. When the meter is set to cord mode but no sync cord is attached, pressing the meter's flash activation button will not fire the flash. In either case, the meter may indicate an exposure error or underexposure when the button is pressed. In cord mode, the meter may provide an ambient-light exposure reading if there is sufficient light to provide a reading for a non-flash exposure.

(2) In cord mode: Sync cord is not attached properly.

In *cord* mode, if nothing happens when the activation button is pressed, check that the sync cord is properly attached to both the camera and flash unit. The strobe may not fire without a secure contact.

(3) In cordless mode: Meter has been left idle for too long.

In *cordless* mode, if the meter is in stand-by, an icon should be flashing. If no icon is flashing, it's possible, especially with digital LCD meters, that the meter has shut off automatically if it has been left idle for too long.

(4) Batteries in the meter need to be replaced or an electronic condition may be interfering with normal operation.

Before changing the batteries, first switch the meter off, wait a few moments, and turn it back on. This step should reset the meter. If this fails, and if the batteries are fresh, switch the meter off, remove the batteries, and reinsert them, making sure they're inserted with the proper polarity. Then switch it on. If that doesn't work, recheck sync connections first (if using a sync cord) before sending the meter in for repair.

Flash-ready signal fails to light, even after a minute, on a battery-operated unit.

(1) If the ready light fails to come on after 30 seconds, especially if you don't hear a high-pitched whine indicating that the capacitor is charging up, the batteries may be exhausted.

Turn the strobe off and replace the batteries.

(2) Capacitor needs to be formed.

Form the capacitor (with fresh batteries).

Self-timed exposures are relatively easy but do require some planning. Here an infrared camera release would have given the author time to compose himself suitably. Activating the self-timer on the camera manually means having to run back into position and very possibly getting caught before you're ready, as was the case here. Also, using red-eye reduction would have been a nice added touch.

Flash sync or first- and second-curtain sync problems.

(1) Wrong sync setting was used.

Set camera or flash to first-or second-curtain sync, as needed.

(2) Settings on camera or strobe are interfering with second-curtain sync operation.

When this setting can be made on both the flash and camera, make certain the same setting is used in both cases, otherwise, one may take priority over the other. Check other operating modes to see where some interference might be occurring.

(3) Camera has no provision for second-curtain sync.

Not all cameras provide a second-curtain sync function.

It's not that a glass window is an impenetrable object. It's just that you have to be a little watchful when using flash. If the lens is not right up against the glass, there is a good chance that it will catch the strobe's reflection in the window.

Flash sync or slaved strobes fail to fire.

(1) Connections are loose.

Check that all connections are securely in place.

(2) Batteries in transmitter or receiver need to be inserted or replaced.

Insert or replace batteries.

(3) Obstacles are blocking the transmitting beam (flash or infrared), or there is electrical interference (radio remote).

Move the slave sensor or receiver to a better location or switch to a different remote-triggering system that bypasses these obstacles. You can also hardwire the system to bypass obstacles.

Flash sync or slaved strobes fire prematurely.

(1) Other strobes or flashing devices are triggering your flash units.

Block the sensor from stray signals; change transmitter and receiver channels if other similar systems are being used nearby. Switch to a different slave-triggering system. Or hardwire the system to bypass inadvertent triggering.

(2) Triggering strobe is emitting a pre-flash that causes the optical slave to fire.

Check that flash is set to manual mode (which should eliminate the TTL pre-flash). Check that the red-eye reduction pre-flash is turned off. Or switch to a lower-sensitivity photo-slave.

Flash sync or studio flash fails to fire.

(1) Sync cord is disconnected or damaged.

Connect, repair, or replace the sync cord.

(2) Polarity is reversed.

Some studio flash units have a reversed polarity. If the flash uses a dual-prong plug, reverse the plug.

Caution: Reversed polarity may damage the camera.

Glaring reflections or hot spots appear in photo.

Flash light was reflecting off shiny surfaces.

Use an off-camera flash or bounce flash. When constrained to using on-camera flash, position the camera at an angle to the subject.

Hard shadows appear directly behind or on the subject.

Direct, on-camera flash was used.

Take the flash off the camera and position it high above the subject or at an oblique angle to the subject. With built-in flash, reposition the camera so the light hits the subject at a more advantageous angle. Use bounce flash. Move the subject away from the background.

Image is partially unexposed.

While this is rarely, if ever, a problem with TTL dedicated systems, this indicates that a shutter speed faster than the appropriate flash sync speed was set.

Check that you've set the correct flash sync speed on the shutter-speed dial.

Manual flash: Exposure error with hand-held flash meter reading.

(1) ISO was set incorrectly on meter, or meter was used improperly.

Be sure to set the correct ISO on the meter. It should match the film speed in use. Metering technique: An *incident-light* meter reading should be taken with the meter held at the subject position and with the white dome facing the camera, while a *reflected-light* reading should be taken with the meter cell (without the white dome) aimed at the surface that is reflecting the flash light. With all handheld flash meter readings, make sure that neither you nor the meter is blocking the light from reaching the target area.

Ordinarily, stroboscopic flash photography should be shot against a black background, in total darkness. Even with all the lights out, the white wall created a problem, reflecting back too much of the strobe's light. Instead of a simple stroboscopic image, it's now a ghostly effect.

(2) Although the flash unit may indicate a full charge, the unit may not have truly completed charging. In that instance, the flash is usable, but not at full output. An exposure reading would not necessarily reflect this partially charged state.

With manual flash, allow a little more time (perhaps as much as half again as long as it took for the flash-ready signal to indicate a full charge has been achieved) before firing the flash or taking a flash reading. The capacitor should have fully formed by then. Auto-sensor and TTL flash should read the actual light output, whether at full or partial charge. Moreover, if you were to take the meter reading before a full charge has been reached and then you wait the full time to take the flash picture, overexposure would result because the meter would not indicate the total light output in the meter reading.

Manual flash: Pictures are poorly exposed.

(1) Flash or camera was set to the wrong operating mode.

Check that you've set the flash to manual mode and the camera to manual or X-sync mode, as appropriate.

(2) F-stop was inappropriate for subject distance.

Check that you've set the lens to the appropriate *f*-stop, matched to the subject distance.

(3) Pictures taken outdoors at night or in a huge open space with walls that barely reflect the light.

Open up 1 to 1-1/2 stops to compensate for light that is not reflected back onto the subject, less if the subject is nearby.

Double shadows should be avoided where possible. The double shadows come from the use of two lights on a bracket, left and right of camera. To make matters worse, shadows looming in the picture might take on a foreboding character, until we stop to think that such shadows don't fall on sky or ocean, which was supposed to be the setting for this lighthouse ornament. On top of that, the picture is overexposed.

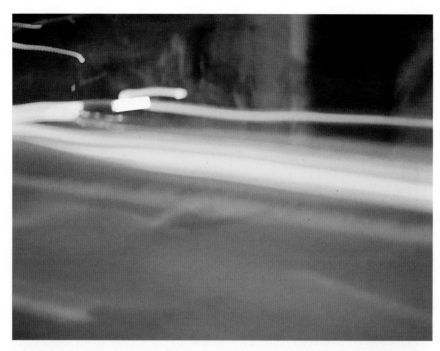

Second-curtain sync produces great effects, unless the exposure is too long and the subject is out of the frame by the time the flash pops.

Red-eye.

Flash light reflects from inside the eyes back to the film as color-tinted light.

There are many solutions to this problem. Use the red-eye reduction mode. Put the flash unit on a bracket. Use off-camera flash. Use bounce flash. Sufficiently high levels of ambient light should reduce the size of the pupils (where red-eye is observed) and make the effect less obvious.

TTL flash exposure error: Subject is overexposed.

TTL flash sensor read dark subject tones and overexposed.

Compensate by *decreasing* the exposure (begin at -1/2 and bracket) with the help of the exposure compensation control or by *reducing* flash output with the flash compensation control. Before and after taking the exposure, check that these controls have not been left with the wrong settings in place.

Off-camera flash fails to fire.

(1) Sync cord problem.

Check sync cord and replace if necessary.

(2) Slave-sync problem.

Check that the off-camera flash is slave-synced. Check that there are fresh batteries in the transmitter and receiver, as well as in the slaved flash. Check that the hard-wired connections are intact.

Overexposure of foreground subject.

Foreground subject is too close to the flash unit.

Try to keep all your subjects in the same plane. If possible, shoot from a diagonal position. Or use bounce flash, trying to keep the light fairly uniformly dispersed front to back.

What's really wrong with this picture can take all day to describe, but suffice it to say that the built-in flash provided too much light to the foreground, not enough for the cat in the background. And the autofocusing lamp couldn't handle the subject distance. But the alien-like, glowing-eyes effect is interesting.

TTL flash exposure error: Subject is underexposed.

TTL flash sensor read bright subject tones and underexposed.

Compensate by *increasing* the exposure (begin at +1 and bracket) with the help of the camera's exposure compensation control or by *increasing* flash output with the flash compensation control. Before and after taking the exposure, check that these controls have not been left with the wrong settings in place.

Underexposure of background or subject in back.

Subject or background was located too far from flash.

Try to keep all your subjects in the same plane. If possible, shoot from a diagonal position. Use bounce flash with an angle sufficient to reach far back, assuming that no obstacles (such as a door frame) block this light from reaching subjects in back and that those subjects are not too far away for bounce flash to be effective. Use a larger *f*-stop or (if applicable) reset ratio control to output more light. Remove diffusion or wide-angle panel from strobe head.

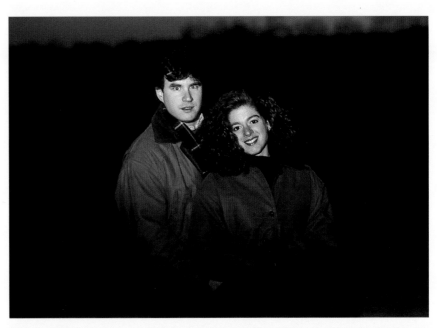

When handholding a strobe, be careful to direct it at the subject. Here we're lucky to get any light on the subjects at all. The flash was held up high to prevent red-eye but held straight, instead of being angled toward the subjects. The result is that the bottom of the picture is vignetted.

Underexposure of foreground subject.

Foreground subject is too far from flash or there is insufficient light output.

Try to keep all your subjects in the same plane. If possible, shoot from a diagonal position. Or use bounce flash, with a tighter and more restrictive angle to keep light to the near distance. Use a larger *f*-stop or (if applicable) reset ratio control to output more light. Remove diffusion or wide-angle panel from strobe head. Switch to a more powerful strobe (from built-in to accessory, for example).

Underexposure with bounce flash.

Light loss was excessive.

Use a larger *f*-stop. Check bounce angle to verify it will cover the distance. Set flash zoom to tele position. Use tele panel on flash head.

Vignetting (using flash).

Flash light did not cover the lens' field of view.

Check that the flash unit's zoom setting (if applicable) matches the lens' focal length. Remove tele panel. Add wide-angle panel. Use bounce flash.

Glossary of Common Terms

Accessory shoe: A specially fitted, rectangular support to which accessories are mounted by way of a sliding foot of similar shape. When this shoe contains electrical contacts, it becomes a hot shoe.

AEB: Abbreviation for auto-exposure bracketing. A feature provided on some cameras which automatically brackets exposures in user-defined increments (e.g., +/- 1/2 stop) around a base exposure. Select cameras extend AEB to flash photography as well as ambient-light exposure.

AF: Abbreviation for autofocus.

Ambient light: A broad term that applies to both natural and artificial light that exists in an environment, including daylight, incandescent lighting, and fluorescent lighting. When we routinely take an exposure reading with the camera, it is measuring the ambient light. Often used interchangeably with available light or existing light.

Aperture: A variable size opening in the lens, also called the *f*-stop, used to control the amount of light that reaches the film.

Auto-aperture: One of several available lens aperture settings, at a given film speed, that can be used with a strobe in automatic (auto-sensor) mode. See also automatic flash.

Autofocus (AF) illuminator: See focus-assist beam.

Automatic flash: Also referred to as auto-sensor flash (to avoid confusion with TTL automatic flash), this describes a type of strobe or a flash operating mode that relies on the flash auto-sensor to control light output automatically. In this mode, one *f*-stop setting, or auto-aperture, covers a range of distances, and so long as your subject stays within this range, flash pictures taken at that *f*-stop will be correctly exposed.

Auto-sensor: A photocell located on the face of the strobe and which operates in non-TTL automatic (auto-sensor) mode to read the quantity or intensity of strobe light reflected off the subject and thereby determine flash duration for a correct flash exposure. Auto-sensor readings may be adversely affected by bright light sources shining into the photocell, which would lead to underexposure. See also automatic flash.

Auto-zoom: Prominently featured on dedicated TTL strobes, this function automatically sets the flash head position to correspond to the lens focal length in use. Manual zooming is generally, but not always, available on auto-zoom strobes.

Available light: Often used interchangeably with existing light and ambient light, although it may more specifically refer to situations involving low light levels.

BCPS: Abbreviation for beam-candlepower-seconds, which is another way of defining light output. Usage is fairly obsolete today. More commonly used values are guide number and watt-seconds.

Bounce card: 1) A card or other reflective device attached to the flash head of a portable flash unit, often at an angle, and used to direct a more diffuse light and possibly catchlights toward the subject. 2) A small reflector, also called a fill-card, on a still-life set.

Bounce flash: A diffused form of light coming off a reflecting surface, rather than directly from the strobe itself.

Bracketing: A technique used to provide a properly exposed photograph when shooting under tricky or unusual lighting conditions or with bright- or dark-toned subjects that may otherwise lead to exposure errors. It involves shooting a series of photographs while varying the exposure. See also AEB.

Confidence light: The small indicator light available on some flash units that signals whether sufficient light has reached the subject for proper exposure.

Daylight-balanced: 1) The color balance of a film designed to be exposed under 5500° K (Kelvin) light. 2) A light source providing this color balance, such as electronic flash.

Dedicated: A design that restricts some or all functions to devices configured as matching components. A microprocessor link passes data between these matching components through a common interface, routinely the hot shoe, and controls operation of one by the other. The term most commonly refers to a strobe paired to camera or camera system. See also TTL dedicated flash.

Depth of field: The zone of sharp focus in front of the lens. In the picture-taking stage, three factors increase depth of field: smaller lens aperture, greater lens-to-subject distance, and shorter lens focal length. Reversing one of these factors will reduce depth of field accordingly.

Direct flash: The technique by which the flash is aimed directly at the subject, generally resulting in a harsh light riddled with hard shadows.

Duty cycle: The number of times a strobe can be safely and rapidly fired continuously, without damaging the unit. Assuming the necessary circuitry is built-in, the flash may shut down automatically to prevent damage from occurring.

Fill: Generic term for fill-card or fill-light.

Fill-card: Any card serving to reflect light back onto the subject to fill in harsh shadows and reduce contrast. While technically called a reflector, fill-card often refers to small reflector cards used with tabletop sets. See also bounce card.

Fill-flash: Technique employed to lower contrast in subject areas that are in shadow, where key details may be obscured or lost on film. Also known as flash-fill and fill-in flash.

Fill-light: Any light, such as fill-flash, introduced in order to reduce lighting contrast.

Film speed: Describes a film emulsion's relative sensitivity to light. See also ISO.

Flash: 1) A flash unit, also referred to as a strobe. 2) In current usage, photography or lighting involving electronic flash. 3) A burst or pulse of light.

Flash bracket: A support device that makes holding and using a flash off-camera more convenient, but because it is attached at the tripod socket, still forms an integral unit with the camera.

Flash calculator: The mechanical (as opposed to digital or tabular) means by which automatic (auto-sensor) strobes normally provide data on corresponding auto-apertures and flash-to-subject distances applicable for a given film speed, as well as selected f-stops matched to specific distances in manual flash operation. The calculator consists of concentric dials or a slide-rule-type configuration.

Flash confirmation indicator: Also known as the confidence light or the flash distance confirmation signal (or any variation thereof), this indicator lights to tell you that the subject is within range of the flash for a correct flash exposure. The confidence light is found on the back of the flash unit. Sometimes this signal is provided via the same function that provides the flash-ready signal. In this case, a blinking indicator may signal that the light was insufficient to cover the subject.

Flash coverage: The cone of light output by a strobe to match the angle of view of a specific lens (normally stated with respect to 35mm camera lenses). Flash coverage data may be given for a nominal focal length or for the entire range of applicable auto-zoom settings. This is also referred to as beam spread. See also vignetting; flash range.

Flash duration: The intensity of the flash pulse in terms of the length of time that a light burst is emitted by a strobe. The flash duration can range from 1/50,000 second down to 1/1,000 second. Flash duration in combination with the lens aperture determines flash exposure.

Flash head: The part of the flash unit that houses the flash tube and flash reflector.

Flash meter: Any handheld exposure meter that reads electronic flash output and provides an exposure reading in f-stops, based on an ISO and flash sync speed set on the meter. Most flash meters read ambient light as well.

Flash output: The actual volume of light produced by a flash unit. Often used synonymously with flash duration.

Flash range: Indicates the minimum and more importantly, maximum subject distance the flash will reach, with the values provided for a specific film speed and lens focal length.

Flash-ready signal: The indicator that confirms that the strobe has reached a full charge and is ready for use. Also referred to as the ready light.

Flash reflector: The rectangular or circular reflective metal surface (or dish) that surrounds the flash tube and directs light out toward the subject. Flash reflectors (often referred to simply as reflectors) are interchangeable on many studio flash heads to provide varying lighting effects and coverage.

Flash sync: Short for flash synchronization, this is the fastest allowable shutter speed that may be used to synchronize the exposure (specifically, the shutter curtain movement) with the flash firing once the shutter button is pressed fully. Select types of cameras or operating modes may set flash sync automatically. Also referred to as sync speed and more technically, X-sync.

Flash tube: A gas-filled tube that emits a short pulse of light when it receives a triggering voltage.

F-number: Refers to the numerical value given to a lens aperture. A small f-number indicates a large aperture and as the f-number increases, the aperture size decreases.

Focus-assist beam: The infrared beam that helps the camera to focus automatically under low-light conditions or with low-contrast subjects. It is also found on strobes designed for AF cameras and may take the place of the camera's AF beam to help in similar situations. Also called auto focus illuminator.

FP sync: See high-speed sync.

Fresnel lens: A thin lens with a series of concentric prismatic grooves on its surface. Flash units with zoom heads usually have a Fresnel lens in front of the flash tube. Changing the distance between the lens and the flash tube adjusts the angle of coverage.

F-stop: See aperture.

Gray card: A neutral-gray-toned card that reflects 18% of the light striking its surface. This card may be used as a key subject tonal value when exposure is measured with a handheld reflected-light meter or with the camera's metering system. It may also be used when making tests involving any type of meter or strobe, as a standard value against which correct exposure is judged.

Guide number: This value defines the relative efficiency of the strobe and is often thought of in terms of how powerful the flash unit is. The higher the guide number, the more light the flash unit produces under a given set of conditions. Variables include film speed, the flash-to-subject distance, accessories that modify the light, use of the power ratio control, and the overall construction of the flash head. The value may be stated in meters or in feet and is normally given for ISO 100 film and if applicable, at different zoom settings. Abbreviated GN.

Handlemount flash: A strobe unit where the grip or handle is normally permanently attached to the flash head.

Highlight: In exposure, an area of the subject or scene that reflects considerable light or is inherently brighter and which may hold detail of importance to the exposure.

High-speed sync: Also known as FP (focal-plane) sync, this flash synchronization mode permits you to shoot at a range of shutter speeds that exceeds the maximum allowable flash sync speed.

Hot shoe: The accessory shoe on the camera which carries electric/electronic signals between the camera and a compatible flash or flash module seated in this shoe.

Hot spot: 1) In exposure, an area on the subject or in the scene that is glaringly and distractingly bright; an overly brilliant highlight. 2) In lighting, the circle of light that is obviously brighter than the peripheral areas.

Inverse square law: Defines light fall-off. More precisely, the amount of light reaching the subject is inversely proportional to the square of the distance from the light source.

ISO: Numerical film speed rating, according to procedures established by the International Standards Organization (ISO). Formerly ASA (based on American Standards Association). Today, the ISO value can be automatically set on 35mm cameras (and where applicable, the associated dedicated strobe) equipped to read the DX coding on the film cassette.

LCD panel: Found on select strobes (and many cameras), this is the liquid crystal display, which shows all settings, functions, and exposure-related data.

Light bank: A flash accessory whereby light coming out of a flash head passes through a diffusion panel (in a manner similar to window light filtering in through sheer drapery) to provide a soft, wraparound light. Popularly known as a softbox.

Manual flash: A strobe unit or a flash operating mode requiring user input of *f*-stop and flash sync speed.

Manual ratio mode: A separate manual flash mode or simply an extension of the existing manual mode providing control over how much light the flash outputs. See also power ratio setting.

Mode selector: A switch or button that takes you from one operating mode to another.

Monolight: See self-contained strobe.

Multiple flash: The use of two or more strobes in combination to light a subject.

Nickel-cadmium: A rechargeable battery technology that is popularly used as an alternative to alkaline-manganese cells in flash units and elsewhere. Abbreviated NiCd.

Non-TTL auto: The conventional automatic flash exposure mode that uses the flash unit's own auto-sensor. We may refer to it as auto-sensor flash, non-TTL auto flash, or simply automatic flash.

On-camera flash: Refers to any strobe, either built-in or accessory, used on the camera.

Open-flash button: See test button.

OTF flash: Now a somewhat obscure term largely replaced by TTL flash, this represents the process by which flash illumination enters through the lens and is measured in the camera by a photocell designed to read flash illumination after it bounces off the film plane (either the film itself or shutter curtain).

PC terminal: The X-sync socket on the camera body designed to work with a standard, non-dedicated PC/sync cord.

Photographic umbrella: To all outward appearances, a conventional umbrella but without the handle, where the interior surface is white, silver, or gold and used to bounce strobe light back onto the subject in a softer form.

Portable flash: Any flash that may be conveniently carried outside the home or studio and normally operates on battery power.

Power-pack system: A studio-type flash system operating off AC line voltage, where the power supply—the power pack—is separate from the flash head.

Power ratio setting: Variable power settings that reduce light output in well-defined increments, available on select strobes when the flash unit is set to the manual mode or manual ratio mode, and on some strobes in automatic mode. Because this in effect changes the guide number, it is also known as the variable GN setting.

Pre-flash: The preliminary, ultrashort light burst or series of light pulses emitted by a TTL dedicated flash and used by the camera to determine the flash exposure for the main flash burst that follows. This may only apply to select TTL auto flash modes and/or strobes in combination with select cameras and/or off-camera adapters.

Ready light: See flash-ready signal.

Recycling time: The time it takes for the flash capacitor to reach a full charge after the strobe has fired and discharged some or all of the stored energy. Recycling time directly relates to flash duration (shorter duration, faster recycling) and to the type and condition of the batteries used.

Reflector: 1) A device used to bounce light back onto the subject. 2) The metallic dish surrounding the flash tube.

Remote-triggering device: Any device used to trigger a remote, off-camera strobe. Remote-triggering devices operate photo-optically, or by infrared signals, radio frequencies, audible sound detection, or motion detection.

Self-contained strobe: A studio-type flash that integrates all components in one unit, much like a portable flash, except that it is powered by AC line voltage instead of batteries. Also called a monolight.

Shadows: 1) In exposure, the dark tones that may be important to a picture, requiring visible detail to be reproduced. 2) Also shadows cast in a scene.

Shoe-mount flash: Any strobe that mounts onto the camera's accessory shoe.

Softbox: See light bank.

Standby mode: The strobe's operating mode that temporarily shuts the flash down after a certain period of inactivity to conserve battery power. The unit returns to full operational status after activation signals are detected.

Stroboscopic mode: Flash operating mode which fires off a series of pulses in rapid succession, letting you capture rapid movement as a stop-action sequence.

Sync speed: See flash sync.

Test button: The button used to fire the flash independent of the camera. It often doubles as the flash-ready signal. Also known as the open-flash button.

Thyristor: The energy-saving circuitry used in many battery-operated automatic flash units. This circuitry recycles energy that was not fully expended after the flash popped, to shorten recycling times while at the same time prolong battery life.

TTL auto: The flash exposure mode on a TTL dedicated flash that takes advantage of the advanced circuitry and light sensor in the camera to read ambient light and control flash output. Proper operation may require a related mode setting on the camera.

TTL dedicated flash: Describes a flash operating mode or a type of strobe unit that operates by way of an in-camera flash sensor. This involves a data exchange between the camera and flash to control flash output through a complex network of microcircuitry that uses the hot shoe or a similar interface as the messaging conduit between camera and flash. Also referred to as dedicated TTL flash.

Variable GN setting: See power ratio setting.

Vignetting: 1) Light falloff, or a darkening, toward the edges and corners of the frame. This occurs when a flash is used in such a way that the beam of light covers only part of the subject. See also flash coverage. 2) Image cutoff toward the corners and edges of the picture caused by an object, usually a lens shade or filter, protruding into the frame.

Watt-second: Abbreviated W/S or WS, this is a unit of measurement that defines how much stored energy is available to a strobe. Often used in conjunction with studio flash systems. In Europe, the preferred term is the joule.

Wireless mode: 1) Flash operating mode on dedicated strobes that lets you trigger a compatible dedicated flash off the camera without a connecting cord, provided another dedicated flash (e.g., the built-in flash) is physically connected to the camera. 2) Also refers to cordless flash meter operation.

X-sync: 1) The flash sync speed or setting on the camera which is required for the flash to be triggered at the correct moment to coincide with the shutter operation. 2) A flash sync mode on the camera whereby a non-dedicated strobe can be used by way of a standard PC cord connected to the camera's sync terminal.

Appendix I

Flash Maintenance

Every flash unit, no matter how high- or low-tech, must be maintained properly so that it can consistently deliver good results from the first pop to the ten-thousandth, or even beyond. Following are general maintenance procedures. Consult the instruction manual that came with your flash unit for specific steps that apply to the strobe you own. Please note that while camera manufacturers may not outline specific guidelines to maintain a built-in flash, you should also follow these steps where applicable. These procedures also apply to handlemount strobes and with obvious exceptions (such as battery usage), to studio strobes as well. If you have doubts or questions about a strobe's operation, contact the manufacturer.

• Subjecting the strobe to high temperature, high humidity, or shock may damage the unit. Do not store or leave the flash where heat and/or humidity can build up. Also, keep it out of direct sunlight. Further, extremely cold temperatures may impede flash operation.

• When the strobe is brought indoors from the cold, condensation may form inside the sealed flash head. When moving from a cold, dry environment to a warm, more humid environment, enclose the flash under your coat or inside the camera bag or a plastic bag, allowing a few moments for the equipment to acclimatize once indoors. If condensation has already formed, allow a few minutes for the condensation to evaporate. Do not go back outside into the cold, which could result in the condensation freezing and forming potentially damaging water droplets inside the unit when the ice melts, once the unit is returned to a warmer environment.

• The first time the strobe is used, even with fresh batteries, it may take a short while to build up a charge in the flash capacitor. From that point on, the flash capacitor is designed to be used regularly.

If it isn't, it grows stale from lack of use and may take longer for the flash to charge up initially. To condition the capacitors, insert fresh batteries and turn the flash unit on for a few minutes every few months. If the strobe has not been used in some time, especially if it appears to take longer than necessary for the flash-ready signal to light when the strobe is switched on, do the following: Form the capacitors by waiting for the ready light to come on, then fire the strobe so that it expends a full charge. Some manufacturers recommend you do this several times before using the flash for normal operation. The strobe should perform reliably after that.

• The only strobes designed to be grabbed by the grip/arm are handlemount strobes. Shoe-mount flashes on a bracket, like handlemounts, may also be grasped by the grip/arm. Never pick up a camera by the flash seated in the hot shoe. The base of the flash was not designed for such stresses. Serious damage could result.

• Flash units are designed to provide rapid-sequence operation only up to a point but may shut down or delay firing when their internal circuitry triggers potential overheating from overuse—when they've exceeded a specified duty cycle. Allow the strobe time to recover before continuing to use it for another rapid series of exposures. Failure to do so may damage the unit.

• LCD panels may fade under the following conditions: (1) In cold weather, in which case simply allow the unit to warm up, preferably to room temperature. (2) Over time—at least 5 years—the liquid-crystal display (LCD) is expected to fade and should be replaced by a qualified technician. You may find these displays last much longer, unless the display is left on continually. (3) A crack in the panel may affect readability and functioning, although the strobe may continue to function properly otherwise. It's best to have it repaired by a qualified technician.

• Do not use solvents, alcohol, or other chemicals to clean the strobe or any plastic parts covering the flash tube or sensors, or allow the flash to come in contact with these materials. Use only a soft, dry cloth or silicone-treated cloth, as per your instruction manual.

• Sync cords should make positive contact. Do not operate a strobe with a damaged sync cord. Also, standard PC cords sometimes slip free of the PC terminal, or the connection may be loose, resulting in a failure of the strobe to fire when the shutter button is pressed. It may be necessary to replace the sync cord. Furthermore, turn the strobe off when connecting sync cords to prevent accidentally firing the flash when the connections are made.

• Keep all sync cords and sync extension cords away from children and pets, and don't leave cords dangling anywhere. Do not allow cords to lie exposed on the floor, where someone may trip over them. Do not tug on the wire but remove by grabbing the plug and pulling free. It may be necessary to release a catch or loosen a knob before removing the sync cord from the connected unit.

• Always unplug the strobe from the wall AC outlet or AC adapter when not in use. Keep all electrical cords away from children and pets and otherwise follow precautions cited for sync cords.

• Manufacturers advise that using lenses other than their own may provide unreliable auto-zooming on the dedicated strobe.

Caution: *Camera manufacturers advise against using any components not specifically designed, recommended, or approved by them for use with their cameras or strobes and that such usage may result in malfunction or damage and that it may void warranties on their products. Tampering with a strobe is also ill-advised and may result in voiding the warranty.*

• Never disassemble a flash unit. The flash capacitor—the internal part where a charge accumulates in preparation for the next flash use—holds high voltages. There are no user-serviceable parts inside the flash, and serious injury can result if you tamper with it. Refer all repairs to an authorized service technician.

Caution: *Don't mix and match strobes. To prevent misfiring or damage, do not use a shoe-mount flash or flash module with a camera where the hot-shoe contacts do not match, unless otherwise specified by the manufacturer.*

Caution: *The face of the flash tube gets hot when it fires and contact with skin, flammable materials, or delicate fibers must be avoided, since this hot surface may burn anything that comes in direct contact.*

Caution: *Do not operate the flash in the rain or allow it to come in contact with water, unless it was designed specifically to operate under these conditions. This may result in electric shock to you as a result of the high voltages carried by the strobe. If rain falls on the flash, blot dry immediately with a soft cloth or tissue. If snow falls, first try whisking it away with a soft brush, but do not blow on it, as warm breath may melt the snow. If the snow begins to melt, blot the area dry.*

Appendix II

Battery Care

Batteries are an integral part of the popular portable strobes we use every day. They must fit the needs of the strobe and be properly maintained to provide reliable flash performance.

• In the event of battery leakage, clean the battery compartment's terminals by rubbing away any dried chemical residue with a pencil eraser, being sure to blow out the residue afterwards with an air-bulb or canned air. Be careful to avoid contact with leaking acid, if still in a liquid state. Thoroughly wash hands after discarding batteries. If leakage is fresh, clean terminals with a dry cloth. Wait a few moments, then clean again with the eraser to remove any dry, powdered residue. Discard all spent batteries properly. Where applicable, recycle (consult your local retailer).

• To ensure proper flash performance in very cold weather—not necessarily Arctic cold but general winter conditions, use nickel-cadmium (NiCd) batteries, unless the manufacturer advises against them. As an alternative, keep the flash and batteries—or the batteries alone—warm and dry until ready for use. Or use an external battery pack that rests under your coat, against your body. Fresh batteries perform better than old ones in the cold.

• Use fresh disposable batteries or freshly charged rechargeable cells, as applicable to your flash. Do not mix old and new batteries, because old cells drain new ones or simply prevent the unit from operating. Also, do not mix different types of batteries. Always keep a fresh set of batteries on hand to replace exhausted batteries.

• Battery terminals tend to oxidize, which forms a layer that impedes current flow. When first installing batteries, and periodically, wipe the battery terminals with a rough cloth or a rubber eraser. After using an eraser, be sure to clean off any residual particles that might remain on the terminals.

• Remove batteries immediately after using the flash, unless you expect to use it again right away. Manufacturers note that you can wait several weeks, but weeks may turn into months before you remember that you left the batteries in there. All this is to prevent battery leakage, which may corrode the contacts and damage the strobe. Also, don't leave batteries in the flash once they begin to weaken considerably (when recycling takes an inordinate amount of time), because batteries in this condition tend to leak more readily. Even NiCd cells may leak.

• If the flash does not operate after fresh batteries are inserted, check that batteries are not inserted backwards, with reversed polarity. If they are left inside the unit in reversed position, the batteries may leak or other damage could occur. If this is not the problem, check that the contacts are clean, or refer the unit for servicing.

• If you haven't used NiCd batteries for at least two weeks, chances are they will be weak, but not completely depleted. Drain the charge by putting them in a flashlight or radio and leaving it turned on until the unit stops operating. Recharge all batteries at the same time. NiCd cells are best when freshly charged. However, never put non-rechargeable batteries in a battery charger or use a charger designed for one type of rechargeable battery with another type of cell. The batteries may leak or explode. Follow instructions as they apply to your battery charger.

• Always switch the flash unit off after use to prevent battery drain and possible leakage.

• Use the battery types recommended by the manufacturer. Portable strobes routinely operate off AA batteries and may accept either alkaline-manganese or nickel-cadmium (NiCd) cells. When freshly charged, NiCd batteries provide faster recycling and better low-temperature performance, compared with alkalines. However, alkalines deliver more flashes per set of batteries when weighed against one fresh charge cycle for NiCd batteries. Also be aware that not all NiCd batteries are the same length or feature the same type of terminal, and a loose fit should be avoided to prevent intermittent flash failure or damage. The manufacturer may offer special NiCd battery packs to handle more demanding strobe usage, or for specific strobes. Carbon-zinc batteries are not recommended. Regarding new battery technologies and high-voltage packs, consult the strobe instruction manual or the manufacturer. Manufacturers often advise against using batteries aside from those they specifically recommend.

More Books in
The Kodak Workshop Series

Advanced Black-and-White Photography (KW-19)
Features techniques for achieving high quality at both the camera and darkroom stages of making a photograph, with emphasis on image control, appearance, and fine-art presentation. Includes toning comparisons as well as a section on hand-coloring prints. Over 140 illustrations. Softbound. 8-1/2 x 11″. 104 pp.
ISBN 0-87985-760-9
Cat. No. E 144 1849

The Art of Seeing
A Creative Approach to Photography (KW-20)
Shows you how to take better photographs by studying the elements of the subject, using lighting, composition, color, shape, form, texture, and viewpoint. Explains how cameras, lenses, and films see differently from you. Suggests ways to achieve creativity by shattering preconceptions and lack of awareness. Helps you break through creative barriers. Over 170 illustrations. Softbound. 8-1/2 x 11″. 96 pp.
ISBN 0-87985-747-1
Cat. No. E 144 2250

Black-and-White Darkroom Techniques (KW-15)
Describes the steps for developing, printing, and finishing black-and-white photos. Includes choosing photographic papers, dodging and burning, mounting prints, and more. Over 190 illustrations. Softbound. 8-1/2 x 11″. 96 pp.
ISBN 0-87985-274-7
Cat. No. E 144 0809

Building a Home Darkroom (KW-14)
These step-by-step instructions on building a prototype darkroom will help you plan and build your own. Covers all you need to know about selecting a location, construction, plumbing, electrical, and more. Includes a wall chart for processing Kodak black-and-white films and papers. Over 150 illustrations. Softbound. 8-1/2 x 11″. 96 pp. ISBN 0-87985-746-3
Cat. No. E 143 9991

Close-Up Photography (KW-22)
Covers equipment, lighting, focusing theory, and exposure calculations for close-up photography. Includes tips on controlling movement, foreground, and background, plus sections on "hands-and-knees" photography and using a close-up camera with hobbies and crafts. Over 130 illustrations. Softbound. 8-1/2 x 11″. 96 pp.
ISBN 0-87985-750-1
Cat. No. E 144 1161

Existing-Light Photography (KW-17)
Discusses the use of high-speed films; camera handling for steadiness; lenses; the correct film for tungsten lighting, fluorescent lighting, and mercury-vapor lamps; and filters. Includes tables that give exposure recommendations for taking photographs in typical existing-light situations, such as in the home, outdoors at night, and in public places. 200 illustrations. Softbound. 8-1/2 x 11″. 88 pp.
ISBN 0-87985-744-7
Cat. No. E 144 1179

Lenses for 35mm Photography (KW-18)
An in-depth guide to lenses for 35mm photography. Sections cover the best lens choice for any photographic situation, including architecture, landscape, wildlife, portraiture, travel, and still lifes. This valuable reference provides information on lens characteristics, optical performance, lens accessories, maintenance, and how to buy new or used lenses. Over 200 illustrations. Softbound. 8-1/2 x 11″. 112 pp.
ISBN 0-87985-765-X
Cat. No. E 144 1757

Using Filters (KW-13)
Gives creative and technical advice that explains how filters work and how you can use them to capture extraordinary images in color and black and white. Shows how to create mood, add dazzle, render normal colors under artificial lighting, and more. Over 180 illustrations. Softbound. 8-1/2 x 11″. 96 pp.
ISBN 0-87985-751-X
Cat. No. E 143 9868

Using Your Autofocus 35mm Camera (KW-11)
Especially useful for newcomers to 35mm photography. Looks at how cameras work and what accessories, such as lenses and flash units, offer. Also includes composition, picture elements, landscapes, and portraiture. 200 illustrations. Softbound. 8-1/2 x 11″. 96 pp.
ISBN 0-87985-652-1
Cat. No. E 143 9603

For a complete catalog of Kodak books, contact:

Silver Pixel Press
21 Jet View Drive
Rochester, NY 14624
Fax: (716) 328-5078